HAUNTED
HOSTELRIES
of SHROPSHIRE

HAUNTED HOSTELRIES
of SHROPSHIRE

ANDREW HOMER

AMBERLEY

First published 2012

Amberley Publishing
The Hill, Stroud
Gloucestershire, GL5 4EP

www.amberley-books.com

British Library Cataloguing in Publication Data.
A catalogue record for this book is available from the British Library.

ISBN 978 1 4456 0201 1

Typeset in 10pt on 12pt Sabon.
Typesetting and Origination by Amberley Publishing.
Printed in the UK.

CONTENTS

FOREWORD BY LIONEL & PATRICIA FANTHORPE

This book is filled with a wide range of very interesting accounts of many kinds of anomalous phenomena and reported encounters with the paranormal. One of the most intriguing questions is just *why* pubs, inns and hotels seem to attract entities from the world beyond – if such entities really are responsible for so many honest and objective reports about inexplicable events.

There are theories about recordings in the fabric of ancient inns – like the famous 'Stone Tapes' drama. Other hypotheses hint at parallel universes: the so-called 'Worlds of If', and yet others suggest glitches in time that somehow bring today and yesterday into strange, fleeting contact.

Or could it simply be that haunted pubs and hotels hold happy memories of warmth and good company that still attract the souls of those who enjoyed their visits there during their earthly lives – and just occasionally return?

Lionel and Patricia Fanthorpe (President and First Lady of ASSAP)

Lionel Fanthorpe is a well known radio and TV broadcaster, management consultant, lecturer, tutor and author. He and Patricia together have written over twenty mystery titles dealing with their on site investigations of the paranormal from many parts of the world and Lionel has written over two hundred science fiction and fantasy novels and collections of short stories. Their website is: www.lionel-fanthorpe.com

ABOUT THE AUTHOR

Andrew Homer has had a lifelong fascination with anomalous phenomena and especially ghosts and hauntings. He has enjoyed a long and varied career in anomaly research including serving as National Investigations Co-ordinator for the Association for the Scientific Study of Anomalous Phenomena (ASSAP). In 1998 he was awarded the Michael Bentine memorial shield for anomaly research.

Andrew has contributed to many publications over the years and has presented lectures for the FT UnConvention, ASSAP and The Ghost Club, and co-authored *Beer and Spirits*, a popular book on haunted pubs of the Black Country. He has played a key role in numerous notable investigations over many years of anomaly research and has appeared on radio and television programmes. Andrew has investigated reported anomalous phenomena in just about every type of location including castles, stately homes, private houses and, of course, haunted hostelries.

Appropriately enough, when he is not involved in anomaly research, writing or working for RNIB, Andrew enjoys a pint in a real ale pub – haunted of course!

ACKNOWLEDGEMENTS

I am indebted to a number of people and organisations who were kind enough to help with this book. It goes without saying that without the contributions made by the various licensees, hoteliers and customers many of these stories would have remained untold. In particular I would like to thank Lionel and Patricia Fanthorpe for writing the foreword. Lionel is the President of the Association for the Scientific Study of Anomalous Phenomena, membership of which, together with regional group Parasearch, enabled me to include personal recollections of some past investigations carried out with these organisations.

My good friend Gareth Goodwin was invaluable in sharing his extensive knowledge of Shropshire hauntings and some of his own experiences. Thanks also to Teresa Sherwood, Dennis Fox, Stephen Idoine and Ian Smallman, who all helped with providing valuable leads. Additional photographs and artwork were kindly supplied by Sophie Homer (Lilleshall Hall), Sarah McCreery (Old Town Hall Vaults ghost) and Steve Potter (Green Man photograph). Grateful acknowledgement is also due to Tony O'Rahilly/Fortean Picture Library for permission to use the Wem Town Hall ghost photograph. Last, but not least, many thanks are due to Diane Homer for painstakingly transcribing the many hours of recorded interviews that went towards the writing of this book.

INTRODUCTION

Nestling between England and Wales lies Shropshire. Within its boundaries there are ancient market towns to explore, hills designated as Areas of Outstanding Natural Beauty and the Ironbridge Gorge, with its museums and world famous Iron Bridge, a World Heritage Site. Once vibrant with industry and trade during the Industrial Revolution, the River Severn provided the perfect route for transporting manufactured goods from this landlocked county down to the Bristol Channel and beyond. Nowadays the river and the Shropshire towns along its path enjoy a much more peaceful way of life.

Shropshire has no shortage of myths and legends from every corner of this historic county. This is where Wild Edric leads the Wild Hunt in full flight over the Shropshire hills as a portent of war. Giants battle for supremacy over the Clee Hills and the mysterious stone circle of Mitchells Fold is said to imprison a witch who stole milk from a magic cow. The Devil himself, having played cards for souls in The Boat Inn at Ironbridge, then holds court from his seat high up on the Stiperstones. And was King Arthur really Owain Ddantgwyn, who defeated the Saxon invaders at the battle of Mount Badon in the fifth century and held court at the Roman city of Viroconium or Wroxeter, just outside Shrewsbury? Some claim this to be the site of Camelot itself. For a county so rich in myth and legend it comes as no surprise that Shropshire is also steeped in stories of ghosts and hauntings.

The haunting stories in this book concern a variety of licensed properties but the majority by far are public houses and inns. These days there is generally perceived to be little difference between a pub and an inn, and the terms tend to be interchangeable. However, this was not always the case as at one time there were clear differences between the two types of licensed property. Traditionally, inns offered accommodation for travellers as well as providing food and alcoholic beverages. Many of the inns here are described as coaching inns and in the heyday of the great stagecoach routes would have also provided stabling for horses and, in some cases, supplied fresh teams for the onward journeys. Watling Street was one such route which passed through Shropshire and in the seventeenth and eighteenth centuries, before the coming of the railways, carried passengers and mail to and from London.

Many public houses came about as a result of the Duke of Wellington's Beerhouse Act of 1830. In the belief that beer was healthier than gin, the Tory government of the time removed the tax on beer and extended the permitted licensing hours to eighteen a day, from 4 a.m. to 10 p.m. This enabled anyone to brew and sell beer and cider from their own 'Beer House' on payment of 2 guineas. Many existing businesses would set a room aside for the selling of beer and cider and many rooms in residential properties were similarly turned over to the sale of ales. The pub business thrived in Victorian times. There was no obligation to provide food or accommodation but there were distinct advantages for public houses to obtain full inn status if they could. Inns were permitted to remain open for as long as a bed was empty and basic food was available providing a ready means to obtain extra income.

Hostelries of all kinds are a rich source of ghostly activity but why should this be so? Perhaps the answer lies not so much with the buildings themselves, but with the rich tapestry of people who have passed through their doors and shared something of their lives over the years. The emotions, traumas, and in some cases tragedies, all add up to an abundant store of human experience which somehow seems to be able to impinge itself on the present in the form of paranormal activity. This activity is commonly experienced in a number of different ways. The idea of ghosts appearing only as semi-transparent floating figures does not really fit with the majority of reports. In the pages of this book you will read about paranormal activity which can involve any and all of the senses. Such activity may manifest itself as anomalous smells, sounds and even physical contact. Of course, actual figures are seen, and whilst there are no reports of anyone coming to any harm from seeing a ghost, some of the apparitions described here are unnerving to say the least for those who witness them.

Whilst conducting the research for this book it was a real pleasure to meet with all the fascinating people and visit the marvellous hostelries featured. Licensees and hoteliers spend their working lives offering a warm welcome to customers from all walks of life, and in many cases are sharing their own homes. These are hardworking, down to earth people, not easily taken to flights of fancy. Nevertheless, time and time again I came across people who were more than willing to talk about sharing their homes and businesses with a plethora of ghostly residents. Perhaps it is the fact that being a licensee often means living and working on the premises that provides an increased opportunity to experience the paranormal activity as and when it occurs. Most of the licensees in this book take a very matter of fact view of such things and accept that there are times when they, and their customers, are simply not alone.

So is this book proof that ghosts exist? I think the answer depends very much on your point of view. For many people who have never experienced anything for themselves, no amount of proof will probably ever be enough. For those people who share their homes and businesses with ghosts, as the licensees and hoteliers in this book do, no further proof is needed.

The great thing about the hostelries, hotels and other licensed properties in this book is that they all offer a warm welcome to visitors. Furthermore, much of the activity takes place when bars are busy with customers or a hotel room is booked for hopefully a good night's sleep. You probably stand as much chance of having a ghostly

experience for yourself by visiting some of these places as a customer as you would joining an organised 'ghost hunt'. Why spend hours sitting in the dark when you could be enjoying a pint of real ale or a home cooked meal in one of the splendid haunted hostelries of Shropshire.

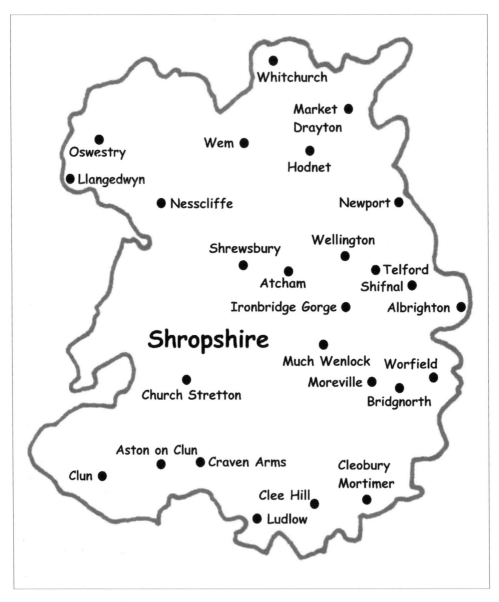

Locations investigated.

ALBRIGHTON

THE HORNS OF BONINGALE
Holyhead Road
Albrighton
Wolverhampton
WV7 3DA

The Horns of Boningale is a lovely eighteenth-century country inn and restaurant. During its 300 year history it once served the somewhat basic needs of Shropshire drovers with allegedly ham and eggs being the only food on offer! Fortunately nowadays an extensive menu is available using all locally sourced produce. A notice on the wall tells of a friendly ghost who switches the lights on in the middle of the night. However, according to Liz Arden, who used to manage The Horns, there is much more to the haunting here than that.

Around 8.00 a.m. one morning Liz let her cleaner in and decided to go down and sort out the cellar as there had been a delivery earlier that morning. Coming up out of the cellar, a corridor leads left or right and Liz had the habit of checking both ways to avoid colliding with anyone walking through. On looking to her left she saw a shortish woman doing something at one of the tables in the dining room. Liz immediately thought this was odd as her cleaner normally started with the copper-topped bar in the other room. Looking to her right into the bar, there was the cleaner busily working on the copper as normal. Needless to say there was no-one else in the building at the time.

One Christmas Liz remembers talking to a wonderful old lady, well into her nineties, who remembered the drovers herding sheep into a barn opposite ready for collection by Staffordshire drovers to take them on to Wolverhampton. This was in the days before lorries of course. The Shropshire drovers would stay over in a bunkhouse which is now the dining room. One night there was a vicious fight in the bunkhouse between two of the men and one was killed. The figure of a man dressed in a smock has been seen by staff leaning against the particularly high mantelpiece in the dining room but oddly his head is never seen. Liz would sometimes have to set the dining room up for

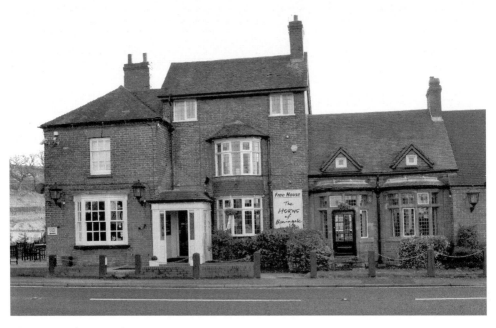

The Horns of Boningale.

big parties the night before but the atmosphere was such that she would never go in late at night on her own. She always took her two dogs with her and all of them were glad to get out when she had finished.

There also seems to be a rather mischievous presence in the pub that Liz and her staff used to call 'Henry'. He was particularly active around the kitchen area and could be very annoying at times when the pub was busy and there were lots of meals to get out. He would continually hide things. Ice cream scoops were a particular favourite for some reason, often disappearing for up to three weeks only to turn up again in an obvious place. On one occasion though, Henry crossed the line from annoying to being quite scary. If he was about an icy chill could be felt even on hot days or if the heating was on. Liz often experienced it, 'It would be like walking into a chill room and walking out again'. On this occasion Liz was in bed and felt the familiar chill of Henry's presence, 'It was late at night and I actually said, Henry just bugger off!' At this Liz felt a hand go through her hair. 'I shot under the sheets afterwards! That was the only time that I really, really didn't like it'.

Down in the cellar various things were often smelt as Liz explains:

You'd go down sometimes and there'd be a really sweaty smell. A working sweat smell when there'd been nobody else down there. I did the cellar work myself there and there'd be nobody else down there. Another time you'd go down and there'd be the most beautiful perfume. And then another time there'd be either a pipe or tobacco smoke smell but then you see if you turn the clock back people would have smoked down the cellars but nobody did when I was there.

Perfume smells are one of the most widely reported phenomena but not generally in locations such as a working pub cellar. However, when Liz related this to the old lady who knew about the drovers she provided a possible explanation. Many years before an infant had died in the pub and in those days it was common practice to lay the body out at home before the funeral. The child was apparently laid out in the cellar and the mother always wore expensive perfume.

Current proprietor, Natalie Jennings, told me that 'Henry' is still up to his old tricks. Bathroom taps get turned on in the middle of the night. The figure in the smock is still seen but now in the cellar as well. During opening hours look out for a chap in a tweed jacket who stands at the bar. He has been seen by various members of staff but when they go to serve him there is nobody there.

ATCHAM

THE MYTTON & MERMAID HOTEL
Atcham
Shrewsbury
SY5 6QG

The Mytton and Mermaid Hotel is a superb Grade-II listed country house hotel nestling on the banks of the River Severn at Atcham. Dating back to 1735, the hotel overlooks the eighteenth-century stone bridge, which also features in the story of the haunting here.

The hotel is partly named after the legendary John 'Mad Jack' Mytton, who was the Squire of Halston Hall from 1796 to 1834. He was aptly named, as Mad Jack never missed an opportunity to indulge in every conceivable excess and reckless venture. Halston Hall was filled with a veritable army of cats and dogs, many of whom he is reputed to have dressed in fine clothes. His favourite horse also had the run of the house and would often lie by the fire like a dog.

Dressed in full hunting attire he once joined his friends for dinner riding a large bear. All was apparently well until Mad Jack decided to speed up the progress of the bear by digging in his spurs. Needless to say the bear took exception to this and gave Jack a severe bite on the leg. Mad Jack appears to have had no regard for his own safety at all and almost seems to have been driven by some sort of death wish. On one occasion he is said to have gone out duck shooting in the middle of the night dressed only in his nightshirt. As if this wasn't foolhardy enough he chose to do it from the middle of a frozen lake.

Such stories abound of Mad Jack Mytton, who at one time purchased a seat in Parliament for himself. He could rarely have been fully sober as his consumption of at least six bottles of port a day and copious amounts of brandy added to his extreme lifestyle. Dinner guests could expect a meeting with the local highwayman on their return home from Halston Hall. Fully costumed and armed with real pistols Mad Jack liked nothing better than to alarm his former guests with the classic, 'Stand and deliver!'

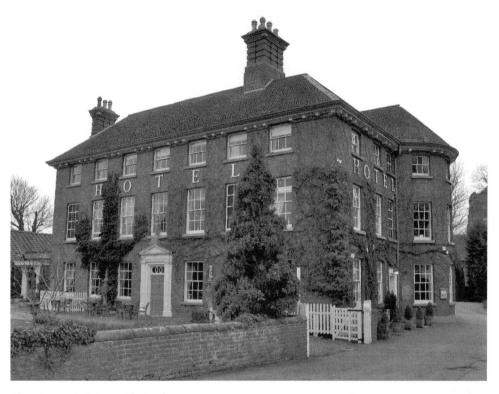

The Mytton & Mermaid Hotel.

Suffering from hiccups one night, Mad Jack decided he needed a good shock to cure them. Dressed only in his nightshirt again he set himself on fire and was only saved by the quick actions of his friends who put the flames out. Apparently it worked and the hiccups were cured. The burns took a little longer.

Eventually, after a relatively short life of extreme excess and eccentricity, Mad Jack Mytton had squandered away his family fortune and he wound up a pauper in the King's Bench debtor's prison in Southwark, London. There he died in 1834, aged just thirty-seven. His body was brought back to Halston Hall to be buried in the chapel there, the funeral cortège stopping on the way back at what is now The Mytton and Mermaid Hotel.

Mad Jack Mytton is an anniversary ghost, the only one in this book, and is said to return to wreak havoc on 30 September each year. Ladies have been known to feel his unwanted attentions on this night and his figure has been seen leaving, not by any of the doors of course, but by leaping from the building. Keep a look out on the old stone bridge as well, for on this night he is seen riding hell for leather across it on his favourite horse, just as he would have done in life. Visit The Mytton and Mermaid hotel on 30 September and be prepared to expect anything from the ghost of John 'Mad Jack' Mytton.

BRIDGNORTH

BASSA VILLA (FORMERLY THE MAGPIE)
48 Cartway
Bridgnorth
WV16 4BG

The Bassa Villa was formerly known as the Magpie House Restaurant. Nowadays it is a bar and grill with five double rooms for bed and breakfast all situated within the main building itself. Dating back to the sixteenth century, it is home to a rather sad ghost story. A plaque on the wall as you enter the bar tells the story of two children who were playing hide and seek sometime in the 1600s. They unwisely chose to use the cellar of the Magpie House for their game. Not realising they were hiding down in the cellar the door was locked behind them and the children were trapped with no other means of escape. Even today, the River Severn is prone to flooding and so it was then when the already flooded river burst its banks and rapidly filled the cellar, drowning the helpless pair. The parents were naturally grief stricken and erected marble busts in memory of their lost children.

Apparently it is not the children themselves who haunt the Bassa Villa but a lady dressed in black sobbing into a handkerchief, who appears in the bedrooms and was seen by a previous landlady to walk through one of the walls. Staff and visitors alike have heard a lady crying uncontrollably and on occasions unexplained laughter coming from somewhere within the building. It seems the lady in black still wanders the Bassa Villa searching in vain for her drowned children.

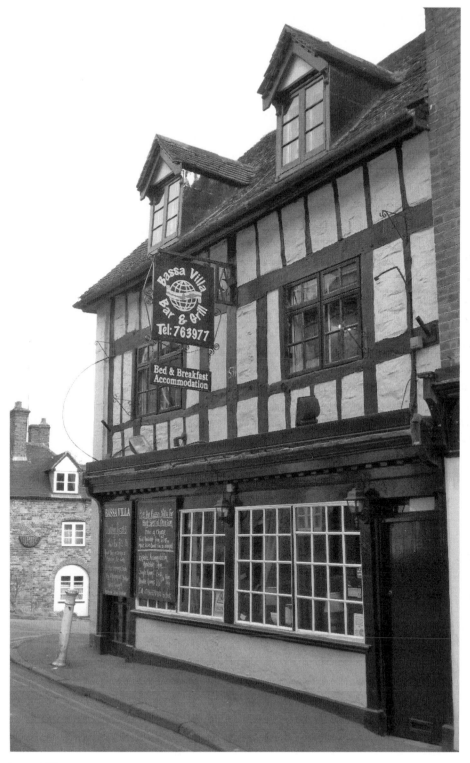

Bassa Villa.

RAILWAYMANS ARMS
Platform 1
Severn Valley Station
Hollybush Road
Bridgnorth
WV16 4AX

The Railwaymans Arms is a very traditional real ale pub which celebrated its 150th anniversary in 2011. The pub is situated on Platform 1 of the Severn Valley Railway heritage line at Bridgnorth. As far as is known the pub itself isn't haunted but over the years there have been a number of reports concerning the railway including one fairly recent sighting.

The Severn Valley Railway hosts very popular 1940s themed weekends with people dressed in both military and civilian period dress. Railway staff and volunteers also dress in uniforms appropriate to the age of steam. Understandably, visitors don't normally think twice when encountering costumed figures here. Railway passengers have even sometimes complimented staff on how authentic the costumed visitors look on the platform outside the pub. Authentic some of them certainly are as on occasions this has happened when there haven't been any costumed volunteers or visitors apart from the uniformed railway staff anywhere on the station.

The railway tunnel on the disused side of the station has also been the subject of odd stories over the years. During the Second World War, a soldier on guard duty was startled by a figure which emerged from the tunnel only to promptly disappear right in front of him. A railwayman carrying tools has also been seen around the Bewdley tunnel. At first he appears to be perfectly normal except he is not wearing the now mandatory high visibility safety jacket. He too disappears without trace before trackside staff can warn him of any danger. In both cases there are reports of early railway workers coming to a tragic end in the tunnels so perhaps they are still working on the SVR line as they did in life.

One of the more recent stories comes from the Shropshire border with Worcestershire where the line weaves its way along the picturesque Severn Valley following the river towards Bewdley. At the very end of Northwood lane the Elan Aqueduct crosses the River Severn. The road ends here at a tiny car park where walkers can follow the footpath further along the valley. It was here in September 2004 that five friends decided to park up after a night out in Bewdley. They were surprised to find a VW camper van already parked there together with a group of people they described as 'hippies'. These people insisted that they were waiting to see the ghost train go by and came here every year to see it. The group of friends decided this was well worth seeing and settled down to wait.

At around 2.30 a.m. in the morning the tracks started to vibrate as if a train was coming from the Bewdley side of the line. What followed will never be forgotten by the five friends who witnessed it. A hazy shimmering mist came down the line described by one of the witnesses as appearing to be something like a heat haze. The grassy bank on the other side of the track could be seen through the haze as it passed by the amazed friends. They could see what seemed to be smoke above where the engine funnel should

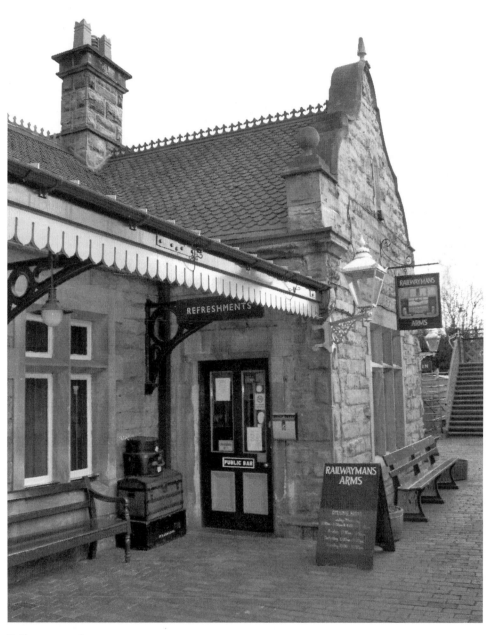

Railwaymans Arms.

have been. All the time the ghost train was passing by the tracks were vibrating. The whole train was estimated to be about five or six carriages long. One of the witnesses described it as being like a train, 'but you could see through it without actually seeing any detail of the carriages or anything'. After the whole thing had passed by the now shocked group, the vibration of the tracks promptly ceased.

Intriguingly, in 1976 the BBC filmed an adaptation of Charles Dickens' *The Signalman* not too far from where this sighting took place. This was a ghost story starring Denholm Elliott and was filmed on the Kidderminster side of the Bewdley Tunnel. September is also the time of year when the SVR runs night trains as part of its annual Autumn Steam Gala. Could it have been local knowledge of this ghost story and misidentification of a Steam Gala night train that conspired to create the ghost train sighting in the minds of the five friends that night? Possibly, except that the witnesses were absolutely adamant about one thing. Apart from the tracks vibrating as the train passed by the whole event was enacted silently.

THE BLACK BOY INN
58 Cartway
Bridgnorth
WV16 4BG

The Black Boy Inn started life in the seventeenth century and pre-dates the English Civil War by a few years. It is a quaint country pub serving a good selection of local real ales. Many of the original features of this Grade II listed building remain including the chimneys and three open fireplaces which create a cozy atmosphere within the pub, especially in the winter months. In summer, customers can enjoy the terrace which looks out over the River Severn.

The pub has an interesting link with the English Civil War. Bridgnorth was very Royalist and the rather curious name of the pub reflects this. When Charles II was exiled in France before the Restoration he would be referred to by the nickname given to him by his mother, Henrietta Maria, due to his dusky looks and dark eyes. Thus Royalist supporters could refer to the exiled King indirectly as 'the black boy' without risk of repercussions.

At one time the Cartway was the roughest area of Bridgnorth. In its heyday it served the rough and ready sailors who worked the busy waterway which the River Severn once was. There were over thirty pubs, numerous brothels and boarding houses stretching from the top of the Cartway to the bottom. It was so disreputable, in fact, that gates top and bottom protected the more genteel folk of Bridgnorth from the bawdy riff-raff contained within.

The Cartway itself, outside The Black Boy, is said to be haunted by the ghost of a lady in black. She is dressed in a long cape and is usually seen late at night. She appears to be a real person until she simply disappears in front of startled witnesses. Her presence is said to make local people wary of walking the Cartway at night. Within The Black Boy cold spots are felt and poltergeist-type activity is experienced. Something here appears to have a dislike of mobile phones. One customer was talking to someone on

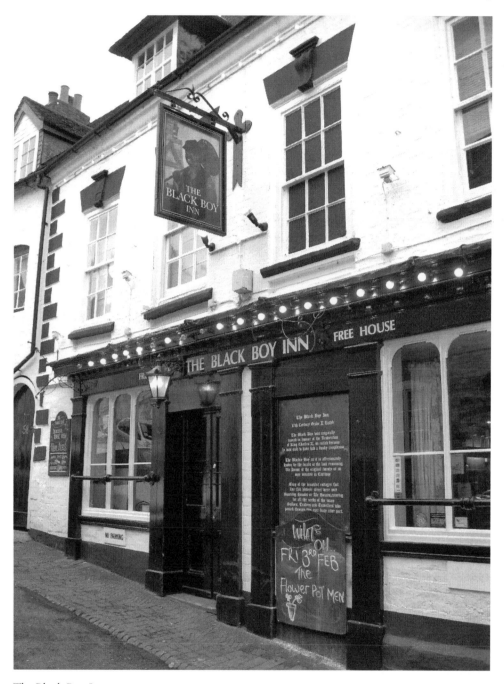

The Black Boy Inn.

his mobile and suddenly felt something pulling on his arm. The phone was literally pulled away from his ear by some invisible force.

Regular customer and local resident, Dean Richards, has also experienced this activity. He was having a drink at the bar and saw a small shot glass somersault off the shelf and smash onto the floor. No-one had touched it or even been near it. The barmaid at the time also saw the glass fly off out of the corner of her eye but Dean was looking straight at it.

A lady in blue has been seen in various parts the pub including the bed and breakfast accommodation upstairs and in the cellar. Nobody knows who this lady might be or whether she is associated with the original building or the later Victorian addition. A previous landlady maintained that it wasn't one female ghost but three, each appearing in different parts of the building.

THE FALCON HOTEL
St John's Street
Lowtown
Bridgnorth
WV15 6AG

The Falcon Hotel is a seventeenth-century coaching inn situated near the River Severn in Lowtown, Bridgnorth. Despite its age the poltergeist-type activity experienced here is put down to a relatively modern ghost. When I visited The Falcon, the staff were generally unaware of the story of Willie, the ghost with a sense of humour. During his life Willie used to visit The Falcon at lunchtimes with his secretary. He always used to joke with staff that they mustn't tell his wife. After Willie died unexpectedly, glasses would shatter for no reason and at least one diner, who had known Willie, had the experience of feeling his presence standing immediately behind her. Instinctively she told Willie she would not tell his wife and the intense feeling of presence faded. The table at which Willie and his secretary usually sat was subject to being thrown into disorder by unseen hands including on one notable occasion, the very day his widow and family had booked for a meal.

The Falcon Hotel has recently undergone a refurbishment which, as noted elsewhere, can sometimes encourage a resurgence of paranormal activity. Having been quiet for a number of years now, Willie may well be overdue for a return visit to his favourite lunchtime haunt.

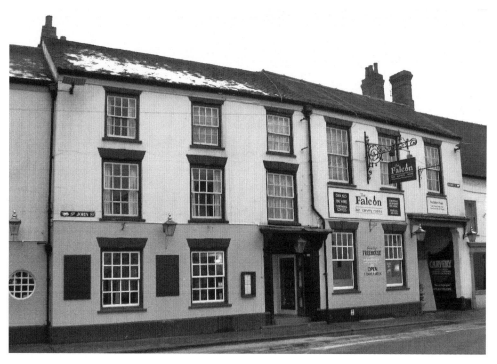

The Falcon Hotel.

THE GEORGE
Hollybush Road
Bridgnorth
WV16 4AX

The George, Bridgnorth, is a coaching inn, hotel and restaurant situated right opposite the entrance to Bridgnorth Station on the Severn Valley Railway heritage line. Indeed, after the line opened in 1862 The George was the local hotel serving the needs of railway travellers. Prior to a major refurbishment in 2009 the hotel was called The Hollyhead after the then landlord.

Stories that the hotel is haunted go back a long time but seemed to reach a peak of activity during its time as The Hollyhead. Inexplicable sounds were regularly heard upstairs including a noise like an old fashioned brass light switch being turned on and off even though no-one else was up there. As is sometimes the case, a downstairs refurbishment seemed to intensify the activity. On one occasion whilst the landlord and a friend were in the lounge late one night a shadowy human form was seen behind the bar. At the same moment the friend felt as though he was on fire and started beating at invisible flames in panic. The whole experience was over as quickly as it began and there was no sign that anything had actually caught light.

Despite being a warm and comfortable place to be, unexplainable fleeting chills are felt in the bar and upstairs rooms. The presence of a woman is also sometimes sensed

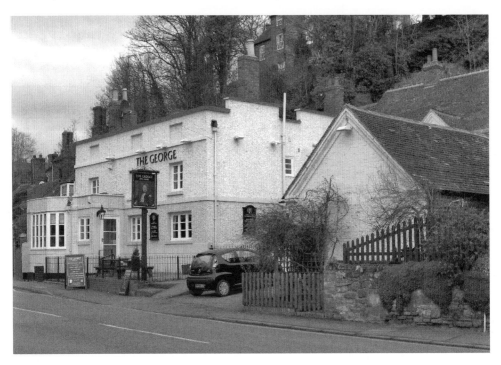

The George.

and usually accompanied by the smell of strong, sweet perfume which disappears suddenly rather than just fading away.

THE SWAN
52 High Street
Bridgnorth
WV16 4DX

The Swan is a beautiful sixteenth-century black and white half-timbered building in the centre of the ancient market town of Bridgnorth. This spacious Grade II listed pub serves real ales, freshly cooked food and also has a beer garden to the rear.

The ghost who haunts The Swan has mainly been seen in the mornings, sometimes before the pub opens but also when there have been customers present. The story is always the same, irrespective of who witnesses the apparition. George, a member of staff from a few years back, tells the following story:

It was in the morning just before we opened. I was at the front of the pub by the main entrance and our cleaner was at the other end of the long bar just finishing up. I was putting some beer mats on the tables ready for opening up. I remember looking up and was surprised to see a man standing a few feet away from me. He was dressed in

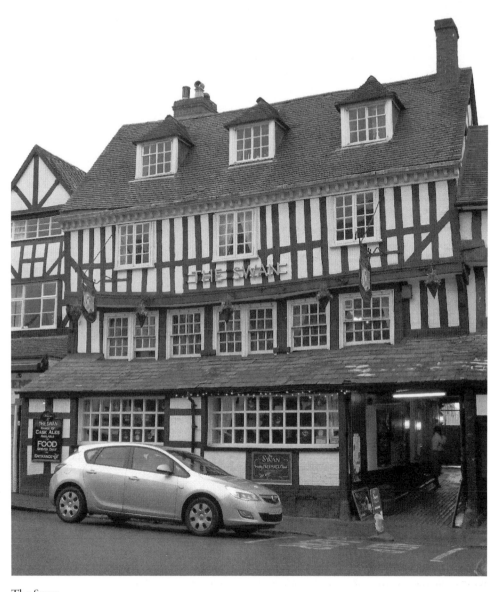

The Swan.

a white suit and was wearing a white floppy sort of hat. My immediate thought was that someone had come in from the High Street. I looked towards the main door but it was still bolted shut from the inside. I looked back towards the man again and he had gone. He had just disappeared into thin air. I shouted across to the cleaner to see if she had seen anyone but she hadn't and we were alone in the pub. When I thought about it afterwards I realised that it was a bit strange for him to be dressed completely in white from his shoes right up to his floppy hat!

Other people have seen the strangely dressed apparition too, but each time when the witness looks away and then back again he has disappeared without trace. George had the impression that his clothes were from sometime around the 1920s era but there is no clue as to who the man might be or why he haunts The Swan.

One of the better known ghosts of Bridgnorth has been seen late at night immediately outside The Swan. A young woman dressed all in black with laced up boots has been seen by local police officers amongst other witnesses. She appears as if from nowhere outside The Swan and makes her way down the High Street towards the Cartway. She has been described as almost floating rather than walking. As soon as she turns the corner towards the Cartway she simply fades away into the night.

THE WHITE LION INN
3 West Castle Street
Bridgnorth
WV16 4AB

The White Lion is a traditional local country pub serving real ales and home cooked food. The pub dates back to 1746 when it started life as a coaching inn. More recently, the building was enlarged when the property next door was purchased. An archway, which can still be seen, led to stabling behind the inn and rooms upstairs provided accommodation for weary travellers.

The White Lion has a number of resident ghosts but there is one particular apparition that you wouldn't want to meet according to the landlord, Bob Hayes. She is called the White Lady and Bob thinks she may have been associated with the long gone White Lady Convent. She is seen as an indistinct, whitish apparition in a flowing gown. Unfortunately, she is a harbinger of death as it is said that anyone unfortunate enough to catch sight of her is certain to shortly die!

A female ghost has been seen on the premises by Bob's father-in-law though fortunately not the White Lady. She was upstairs walking straight across what is now the lounge and just disappeared. He saw her quite clearly in his peripheral vision but when he turned to look directly at her she'd gone. He was absolutely certain he had seen her and said she was wearing a straw bonnet, a shawl around her shoulders and she was carrying a basket.

Unusual things began to happen after a group of psychics visited the pub. They told Bob there were two children upstairs whose mother had committed suicide. Apparently they were upset that Bob hadn't noticed them even though they had been moving

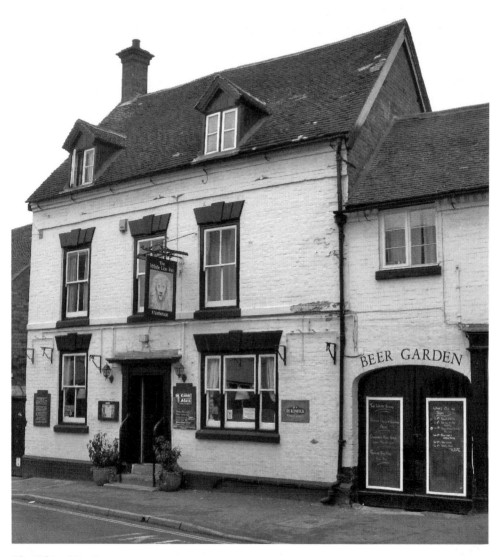

The White Lion Inn.

things around to try and get his attention. Bob's reaction was that they would have to do something fairly spectacular for him to notice with two children of his own on the premises. Bob explains what happened next:

> A few weeks later pennies started to appear on the bar. We cleaned down at night, washed the bar down, took all the bar towels off and cleared the bar. I came in the next morning to clean and there's a penny in the middle of the bar. An old penny, 1906 I think it was. This happened on three different occasions, pennies just appeared, one penny at a time. They were all old; they ranged from 1906 the earliest, and went up to 1920 something I think. They were all quite faded and worn.

After this, unknown to anyone else, Bob decided to challenge the children, or whatever it was, to do something that he would really notice. A couple of days later Bob's challenge was met:

> I went to get a tea towel out of the drawer and on top of the tea towels there was an old hair brush. Wooden backed, quite splayed out and very old, just on its back on top of the tea towels. I thought, 'that's strange' and I brought it out and asked my boys and Sam, my wife, if they had any ideas where this came from – no, they had never seen it before. I left it over on the bar and the next day it was back in the tea towel drawer again! I've no idea how it got there. I'm not particularly fanciful when it comes to such things but it did spook me.

The old commercial kitchen seemed to have been the centre of some poltergeist activity. Coming down to prep some food one morning, Bob went into the kitchen to find all the plates on the floor, mostly smashed. They had been piled up as usual on a solid steel shelf. This was strange enough but on the worktop eight of the plates were arranged in two perfect rows, all in symmetry with each other.

Shortly before Christmas 2010, a plumber was working by himself in the current ground floor kitchen early one evening. He was underneath the sink plumbing in some fittings. Somebody tapped him firmly on the shoulder while his head was under the sink and asked if he was okay. He came out from under the sink to see who was there and the kitchen was empty. Bob remembers him coming into the bar as white as a sheet! After he had calmed down a bit he was able to say that it was a very firm poke to his shoulder and it was a man's voice, very deep.

Ghosts don't only appear at night or when buildings are empty. At the rear of the bar it can get quite narrow especially when people are standing around there. On one occasion Bob saw a lady come in from the door to the beer garden and pass through the group assembled at that end of the bar to go down the corridor that leads to the toilets. She was about 5 foot 2 inches and Bob noticed she had grey hair underneath her headscarf. She was wearing a camel coloured coat. At the time they used to get really annoyed with people just coming in to use the toilets.

On this occasion, Bob decided to play a little trick on the woman as she disappeared off towards the toilets. He waited for a short while and then turned the lights off in

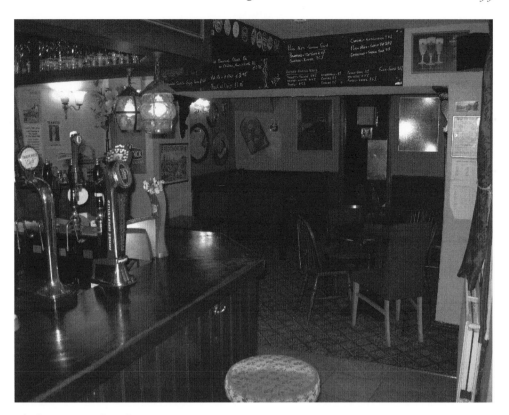

The bar area in The White Lion Inn.

the toilets for a few seconds to give her a bit of a fright. Bob carried on chatting and thought no more about her. After a few minutes one of the regulars who had seen her come in said, 'Where's that woman gone?' as she hadn't come back through the bar, the only possible exit. Concerned that she may have been taken ill Bob went to take a look:

> I went to have a look in the ladies' and there was no one in there, so I thought 'ok' perhaps she's in the gents', no one in the gents'. All the other doors were locked and she hadn't come back through because we'd have noticed her. There was no other way out and she'd gone. That was bizarre and in broad daylight.

If you visit The White Lion Inn, be sure to look out for an old gentleman sitting in the corner. He will be wearing a flat cap with a little dog sitting by his side. No-one knows who he is or how old the gentleman is as he died long before Bob's time at the pub.

THEATRE ON THE STEPS
Stoneway Steps
Bridgnorth
WV16 4BD

The Theatre on the Steps is a unique entertainment venue situated on the age-old Stoneway Steps connecting High Town with Low Town in Bridgnorth. The building dates back to 1709 and was originally constructed as a Presbyterian Chapel and later became a Congregational Church. Locally known as the Stoneway Chapel, it eventually became the Theatre on the Steps in the early 1960s.

Much of the ghostly activity reported here centres around the licensed foyer bar. A lady dressed in green is said to sweep down the staircase and through the foyer. She has also been seen on the balcony and in the auditorium but is sometimes described as being a grey figure. The foyer bar is also home to strange light effects which have been witnessed by different people and on numerous occasions. During an investigation at the theatre the author experienced such an effect which can be best described as a door opening from the area of the auditorium reflecting light onto the opposite wall. Nothing too strange in that you may think except that at the time no doors had been opened or closed and all the lights were dimmed both in the foyer and the auditorium.

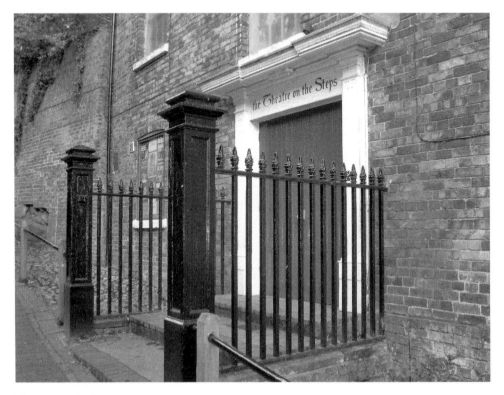

Theatre on the Steps.

On one occasion, the author had agreed to assist with helping a group of nurses who had organised a charity ghost hunt event overnight at the theatre. Not really expecting anything paranormal to occur may even have contributed to the following experience:

I had arrived a little early and walked up the steps from Low Town to meet up with the group. When I reached the theatre a lady called Wendy and her daughter were waiting outside for the event to begin. We got chatting and whilst we were talking we could hear the group on the inside of the building. I banged on the door and continued chatting while we waited to be let in. After a few minutes we had still not been let in but the noise from inside had got louder. We could hear people moving about and occasionally laughing. I banged the door even louder the second time and remember commenting that it was about time they let us in. After a few more minutes we had still not been let in and on hearing someone opening the inner door near to where we were standing I went to bang the door again. Just as I was about to do this Wendy said, 'Wait a minute, some people are coming down the steps'. Sure enough, a group of about twenty ladies led by a man carrying a key on a large metal ring were heading towards us. As the door was unlocked and opened we were still expecting to see the people we had clearly heard inside the building. It was only as the code to disable the alarm was being tapped in that we realised something was not right. As the charity event had been widely advertised my initial thought was that some people had secreted themselves inside the theatre in order to scare the nurses later on. However, a thorough search of the building revealed that it had been empty all the time we had been waiting outside and if not the alarm would surely have been triggered.

This is by no means the first time that people have been heard inside the theatre when there is no-one there. On occasions, staff preparing for a performance have assumed people have gained entry to the bar area only to discover the doors securely locked and the foyer empty. The Theatre on the Steps is certainly an appropriate venue for hosting the popular Bridgnorth ghost walks on Hallowe'en each year.

CHURCH STRETTON

BOTTLE AND GLASS INN
Picklescott
Church Stretton
SY6 6NR

The sixteenth-century Bottle and Glass Inn was waiting to be reopened at the time of writing. Situated in the middle of Picklescott village, it has been licensed since 1837 and was previously a country farmhouse.

The Bottle and Glass has an unusual ghost who is heard rather than seen. He is apparently a man with a wooden leg who is heard tapping his way around the pub when he is active. Odd electrical problems often occur when the one legged ghost is about. Who he is and how he came to lose his leg, in an accident or during military service perhaps, is unknown but he is clearly still very much attached to the old Bottle and Glass Inn.

THE LONGMYND HOTEL
Church Stretton
SY6 6AG

The Longmynd Hotel is situated high above the market town of Church Stretton and is ideally placed for exploring the Long Mynd itself. Meaning Long Mountain in Welsh, this is legendary Wild Edric country where he is said to appear leading the Wild Hunt to warn of impending war. This spectacle is reputed to have been witnessed before both the First and Second World Wars.

A few years back Mandy and Peter James were staying overnight at the hotel after a day's walking over the Long Mynd. After enjoying their evening meal they retired to bed. Mandy James describes what happened during the night:

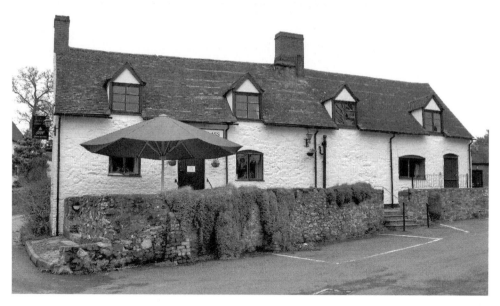

Bottle and Glass Inn.

The Longmynd Hotel.

Although we were both very tired and got to sleep quickly I found myself awake in the early hours of the morning. It was 2.00 a.m. according to the bedside radio alarm. The room should have been completely dark especially with the curtains drawn but it wasn't. There seemed to be wisps of a muted reddish colour swirling around the ceiling. I watched it for a while, not certain if I was still dreaming or not. I decided I wasn't dreaming and nudged Peter to wake him up. The swirling wisps of colour moved from the middle of the ceiling towards the door to our right. As I watched a hazy, misty figure seemed to form in the doorway. I couldn't make out any detail except to say the shape was that of a person. I think I was too surprised to be afraid and nudged Peter even harder and called his name loudly to make him wake up. At this the figure just faded followed by the swirling colours. Needless to say Peter thinks I dreamt the whole thing but I know I didn't. I have no idea what it was but I didn't feel it was anything frightening or unfriendly. I have never experienced anything like it before or since. After this the night passed without further incident and we left as planned the following day.

It is often the case with stories like this that they cannot be confirmed by other people present at the time. In this case of course Peter was asleep but we can never know, had he woken up sooner, whether he would have witnessed the same thing or whether Mandy was having some sort of personal psychic experience.

CLEE HILL

THE KREMLIN INN
Clee Hill
Near Ludlow
SY8 3NB

The Kremlin has been an inn for at least 100 years and before that was a quarry master's house. This welcoming, family, friendly pub serves a range of real ales and traditional bar food. Situated high up on Titterstone Clee the pub enjoys fantastic views and on a clear day up to seven counties can be seen from here. Indeed, at approximately 1,400 feet above sea level The Kremlin Inn is certainly the highest pub in Shropshire and one of the highest in the whole of England.

The pub used to be called The Craven Arms until strange events during the Cold War brought about a change of name. At the height of tensions between east and west, Radio Moscow and other signals direct from Russia used to be regularly heard coming from the jukebox, usually when no records were playing. The landlord at the time described the effect as being, 'quite spooky'.

Titterstone Clee itself has been extensively quarried in past years with the exceptionally hard Dhustone being used for road building. The long abandoned quarries and mine workings at the top of Titterstone Clee can be quite eerie and ghostly even on a pleasant summer's day. At other times dense fogs can quickly descend on the summit of the hill adding to the strangeness of the landscape. It is not a place to be for those ill equipped for hill walking.

The landscape is reminiscent of Arthur Conan Doyle's setting for *The Hound of the Baskervilles*. Indeed, it is generally held that Conan Doyle based his hound on Black Dog or Black Shuck stories which are widely reported across Britain. Conan Doyle's Black Shuck was most likely based on the ghostly dog said to roam the coast of Cromer in East Anglia. Titterstone Clee, however, has its own ghostly dog that is said to haunt the hill around The Kremlin Inn. The large dog usually appears at dusk or at night. Some reports have the dog wearing a jewel encrusted collar and in at least one report he has brightly glowing red eyes. Fortunately, if confronted or approached he will suddenly disappear in front of the startled witnesses.

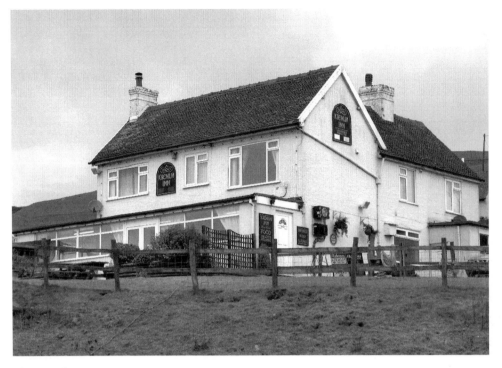

The Kremlin Inn.

CLEOBURY MORTIMER

TALBOT HOTEL
29 High Street
Cleobury Mortimer
DY14 8DQ

The Talbot Hotel is a welcoming sixteenth-century black and white timbered coaching inn, situated in the ancient market town of Cleobury Mortimer. A plaque outside the hotel dates the building to 1551 and confirms that it was an ancient coaching inn. The hotel has been recently refurbished throughout and some of the comfortable bedrooms look out over the distinctive twisted spire of nearby St Mary's Church.

In the cellar of the hotel can be seen a blocked off tunnel which proprietor, Martin Weldon, told me leads to St Mary's Church. This may well have been used as an escape route for Catholic priests during the Reformation. There are other blocked off tunnels too and Martin has been told by a local historian that one of them goes to nearby Mawley Hall.

Immediately outside the front of the hotel there is an historic market cross and an intriguing link with Tudor royalty. Catherine of Aragon's first husband, Prince Arthur, lived with Catherine in Ludlow until his unexpected death from the Sweating Sickness in 1502. She later married Henry VIII and Catherine herself is said to haunt the Castle Lodge in Ludlow as related elsewhere in this book. Local legend has it that after Arthur's death his funeral cortège passed through Cleobury Mortimer on the way to Worcester Cathedral. This was almost three weeks after his death. His body was said to be deteriorating so badly that when they broke the journey here due to bad weather, he was left on the carriage steps under the market cross outside.

The Talbot Hotel is haunted not by Prince Arthur but by a rather mysterious ghost. According to Martin, 'the haunting that I know of is a lady who haunts Room 6 and her name is Mary, but I don't know any other history to her than that'. Apparently when she is around her presence can be felt. If you feel a waft of cold air pass by with no obvious source of a draft you may have just experienced the ghostly presence of Mary.

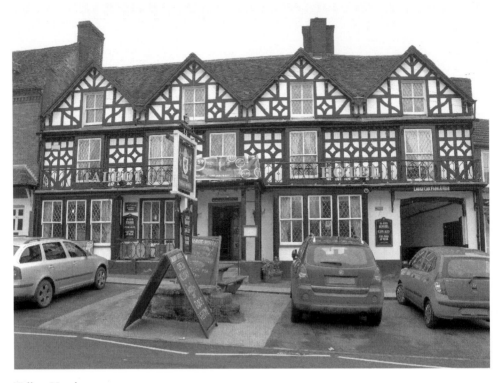

Talbot Hotel.

The blocked off tunnel leading to St Mary's Church.

CLUN AND ASTON ON CLUN

SUN INN
High Street
Clun
SY7 8JB

The Sun Inn is a charming old fifteenth-century country pub situated in the ancient town of Clun. Serving real ales and home cooked food, The Sun Inn also offers comfortable accommodation in the original building and the quiet converted stable block at the rear. This Grade II listed building is of cruck frame construction with exposed oak beams, panelled walls and a magnificent inglenook fireplace in the snug bar. The lounge bar features an original section of seventeenth-century wallpaper which was uncovered during refurbishment work. The building originally started life as a barn to the farm building, now a shop, over the road. This building dates back to the late eleventh or early twelfth century, which makes The Sun Inn very ancient indeed.

Landlady, Lindsey Jeffs, is aware of a good deal of paranormal activity at The Sun. During the two weeks before I visited an odd phenomenon had started occurring in the old bar. There is a dartboard in there and darts simply won't stay put in the board. After a game, common practice is to push the darts into the board but as Lyndsey says:

> You can push them in really hard and go away and five minutes later one of them will drop out. That's a newish phenomenon and last night we were sitting down having a nightcap talking about the evening's events and the beer mats started to come off the walls in the bar – they're all stuck with blue tack. So the dart came out of the board first of all and then the beer mats started to come off at which point I decided to go to bed!

According to Lyndsey one of the most active areas in the pub is the corridor from the bar to the ladies' toilets and the Breakfast Room. The Breakfast Room used to be an old bakery shop and up until the 1970s was a separate building before the pub was

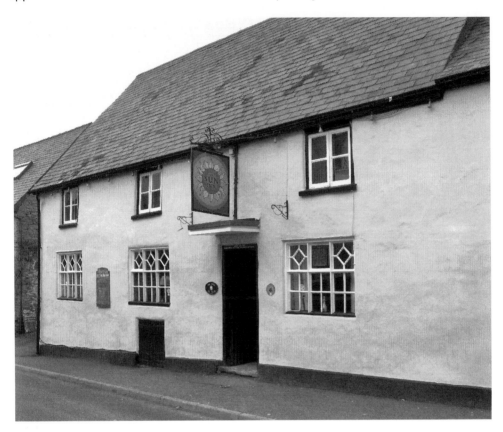

Sun Inn, Clun.

enlarged. Both Lyndsey and the girls who work in the kitchen have had the experience of seeing flashes of white light and movement in this corridor. The activity is always accompanied by a feeling of electricity in the air and the atmosphere noticeably changes. Lyndsey describes the feeling as a 'slight tingle in the air'. They feel she is a female presence, 'a lady in white', and sometimes when she walks past along the corridor she will stop for a moment and have a look. The girls in the kitchen all know when she is about.

A few times Lyndsey has come downstairs in the morning to be greeted by the overpowering smell of freshly baked bread. When it first happened she assumed someone was actually baking bread but this was not the case as nothing was being cooked at the time. The early morning baking bread smell has been experienced by others, too, including a former chef.

Lyndsey has also seen a black figure walking in the same corridor as the lady in white. This is the only presence in the pub that Lyndsey describes as unpleasant:

> The other day when I was in the kitchen just doing food I saw a flick of white go past. I'm on my own at this point and then I saw the black shape come from the right hand side. It stopped and I just knew he was there. I was just peeling something and I

turned and as I looked this shape turned and looked at me at which point I screamed and ran out of the kitchen. I've never ever done anything like that before, never had a reaction like that before.

Upstairs above what was the old bakery are a couple of bedrooms which are only used if friends come to stay as they haven't been refurbished like the pub's other accommodation. The room on the right hand side has always had a strange feeling to it. A few months previously Lyndsey had a friend to stay in the room. She had a great night's sleep and nothing unusual happened until the morning when she was cleaning her teeth at the sink as she explained to Lyndsey:

She said this column of mist appeared by the side of the sink, it was like a column more than a shape and she said she put her hand in it and it obscured part of her hand where she put it in. She looked at the taps to see if it was steam coming from the tap – she's a scientist so she was going through every single thing she could think of to find out what this mist was. She didn't come up with a damn thing then it suddenly disappeared. She said it was so strange but it didn't frighten her. She was trying to be very practical about it but just couldn't explain it.

The bar in the Sun Inn, Clun.

Lyndsey had a similar kind of experience in her own bedroom. An alarm clock, which is only used as a clock, went off at exactly 3.00 a.m. one morning. As she was turning the alarm off Lyndsey realised that that the bedroom was full of mist, 'It was swirling round and round the room.' She was unable to wake her husband to see the mist. 'It eventually came to my side of the bed and then it all just went. It was moving the whole time and then just went.' Lyndsey had never experienced anything like it before but even though it wasn't a column of mist it clearly had similarities with her friend's experience.

In the lounge bar staff and customers alike have seen a man standing by the bar and looking across to the other bar. Nothing too strange in that you might think except, according to those who have glimpsed him, this particular gentleman has a very pointy beard and is dressed in dark clothes reminiscent of the 1600s. Occasionally, people standing in his space by the hatch in the lounge bar for too long have felt a little shove to encourage them to move aside!

Finally, if you see a lady sitting quietly under the clock in the snug keeping herself to herself you may have met with Mrs Marshall. She is the ghost of a former landlady who still likes to keep a watchful eye on the pub. But look again and she will be gone.

THE KANGAROO INN
Clun Road
Aston on Clun
SY7 8EW

The Kangaroo is a coaching inn which was originally part of the historic Oaker Estate. Renowned for its real ales and food it even hosts a beer festival every August Bank Holiday. The building was originally constructed in 1740 but didn't become a coaching inn until a hundred years later. The inn remained part of the Oaker Estate until it was sold in 1949. The name of the inn is something of a mystery in itself. At the time it was named in 1840 the tenant had an uncle who was a navy captain so there is certainly a connection with the sea. The story goes that the SS *Kangaroo* had lost one of its masts and this substantial piece of timber had been used in the building somewhere when it became an inn. The SS *Kangaroo* depicted on the distinctive inn sign was a nineteenth-century Atlantic cable laying vessel.

Aston on Clun is home to Arbor Day which is always celebrated on the last Sunday in May. The present day festival dates back to the Restoration when King Charles II was restored to the throne. Originally called Oak Apple Day, it is associated with the story of Charles evading capture after the battle of Worcester by hiding in an Oak tree. Oak Apple Day ceased to be a public holiday in 1859 but the celebration has continued in Aston on Clun. Tree dressing ceremonies date back even further than this though, and it is likely this celebration has been held as far back as Celtic times.

The inn has a little snug at the front of the building and licensee, Michelle Carloss, told me that people are always reporting something going on in that room. From the bar there is a window through to the front and the bar staff can see whether someone entering the building is coming into the bar or going into the snug. On many occasions

The Kangaroo Inn.

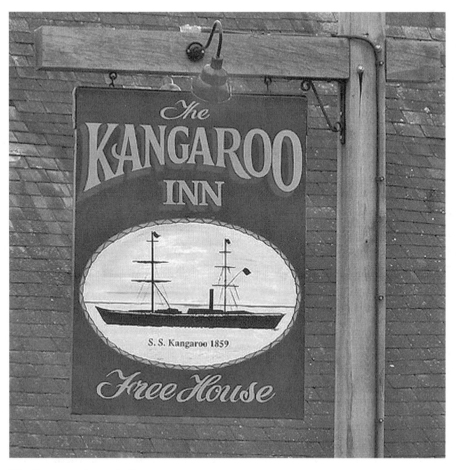

The Kangaroo Inn pub sign.

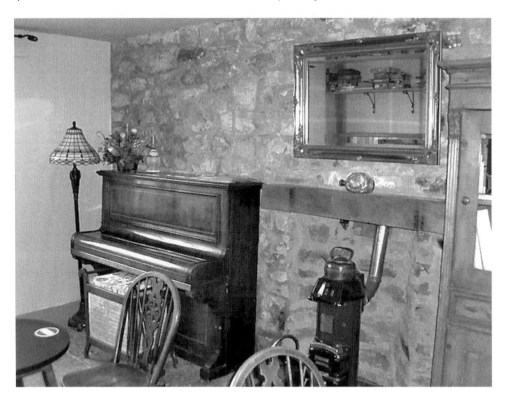

The Snug.

Michelle has heard the front door open and clearly observed someone going into the snug. When she has gone round to serve them there is no-one there and there is nowhere they could have gone. At one time, to give herself a break, Michelle was employing a lady to work one night a week. She ended up leaving because she was so spooked at night when the pub was quiet and the door would open and this figure would come in and enter the snug. It eventually got so bad that before she left she would insist Michelle's mother stayed in the bar with her.

Michelle's mother has had a fair few experiences in the pub. The phone went one day and it was a call for one of the local lads playing pool. She went to pass the big cordless phone to him only to have it wrenched out of her hand. To the amazement of everyone who saw it the phone didn't just fall as if it had been dropped, it shot sideways out of her hand. When Michelle's mother has stayed in the bedroom above the pool room she described it as having a cold, sad atmosphere. She also had the sensation of being tapped on the shoulder by unseen fingers. A visiting psychic was of the opinion that the spirit was that of a sad little girl inhabiting the room who was the cause of the cold, melancholy atmosphere in there. Just inside the front door Michelle and her mother have together had the strange experience of sensing animals moving around them almost as if the building had suddenly reverted back in some sort of time slip to the farm building it once was.

The mirror over the bar isn't just there for decoration. Many times people have been chatting at the bar and felt someone tap them from behind or brush past them. This has happened to numerous people who have no connection with each other or knowledge of the phenomena. The mirror is there so people can quickly check who it is. Usually there is nobody there.

THE WHITE HORSE
The Square
Clun
SY7 8JA

The White Horse is a friendly local pub serving a good selection of real ales, some of which are brewed in the micro-brewery on the premises. Locally sourced, home cooked food is also on offer together with four comfortable bed and breakfast rooms. Landlord Jack Limond has dated the main part of the building back to Tudor times. A splendid plank and muntin screen can be seen which would have originally formed a semi-permanent barrier between the main hall of the house and the parlour. Seventeenth-century wall coverings were discovered when a wall was knocked through a few years ago and typical for this type of building extra rooms and a top floor were added in the 1800s. Given the vicinity of the now ruined Norman castle, and the fact that Clun lay on one of the main sheep droving routes from Wales to the Midlands, Jack believes it highly likely that an alehouse of some sort was on the site which later became a coaching house.

A. E. Housman in *A Shropshire Lad* described Clun as being one of the quietest places under the sun. It was not always so quiet, however. One hundred and fifty years ago it must have been something like the old west when the rough sheep drovers would come into town after penning their sheep up for the night. At that time Clun boasted at least fifteen pubs and was one of the most important and busiest towns in Shropshire.

Nowadays, people still flock to Clun for the annual Green Man Festival in May. This hugely popular event runs over a weekend and culminates with the Green Man defeating the Frost Queen in a battle on the bridge into Clun. This releases the summer which is celebrated with a traditional May Fair on the castle grounds.

There are a number of ghosts associated with The White Horse and they inhabit different parts of the building. Duty Manager, Matthew Bird, told me a disturbing tale involving his fiancé's little niece. At the time she was around two and a half and used to stay regularly at the pub as Matthew recalls:

Every time she walked through the door at the bottom of the stairs she would stop and stand and wave. She wouldn't say why, and then when she got up to the top floor into the flat if the door to Jack's office was open she would not go into the flat until that door was closed. It took about six months to get the story out of her but it was a little old lady on the stairs who always used to say 'Hello' to her.

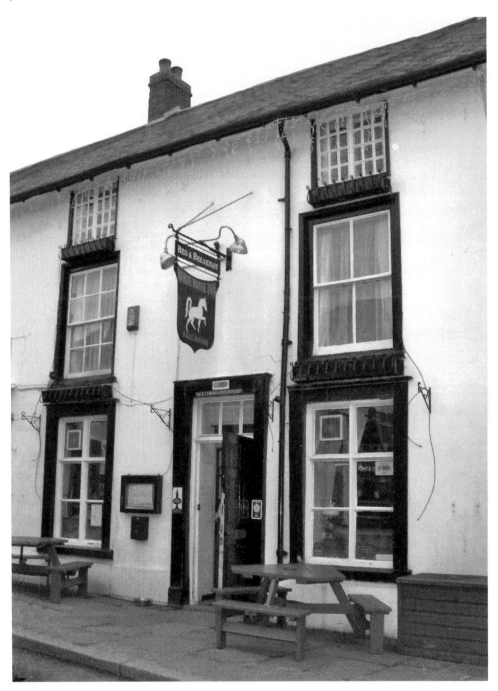

The White Horse.

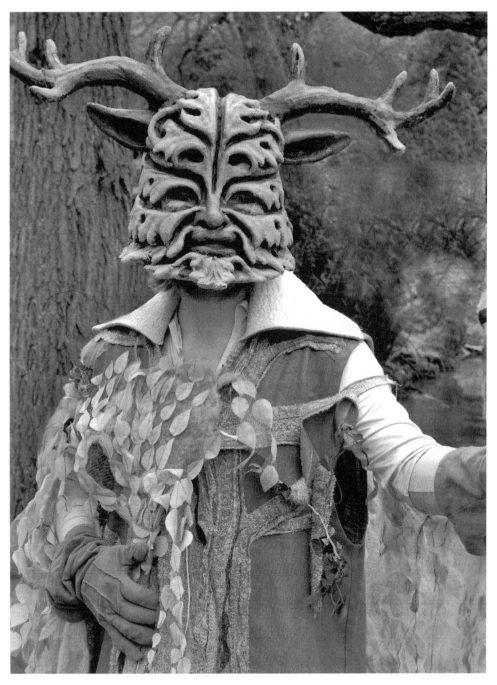

Green Man (photograph by Steve Potter).

The stairs where the 'little old lady' was greeted by the little girl.

Apparently the little old lady always wore gloves and appears to have been a completely benign presence and not at all frightening. Jack and Hannah Limond think that the lady could be the ghost of a previous landlady, Mrs Towers. She went missing around 1977 and was eventually found dead in what is now the Blue Room. Hannah mentioned that the previous landlord had said he had seen Mrs Towers on the stairs himself.

The stairs never bothered the little girl but Hannah confirmed that she always wanted the door to the office closed so she didn't have to see what was in there. Eventually, she was able to say that she didn't like 'the scary man' who was in the room. It's not surprising the little girl was scared by this man as apparently he was hanging by his neck from the ceiling. Strangely though, she used to see the same man in the kitchen when she was eating her meals but in the kitchen she described him as 'nice'. Jack finds the kitchen odd at times and often has the feeling that there is someone there. Hannah was able to add to the story of the man seen in the kitchen:

> There's the mistress there who's linked to the [hanging] man in the office. She's very nice but she's upset because she can't have him to herself but she's happy to do the household chores that he's asking her to do and when he's with her apparently he's very nice.

Jack has done some research into the history of the pub and it seems the hanging man might well be one Job Graves. In the 1860s Job and Elizabeth Graves ran the pub but by the 1890s Job had disappeared from the census returns. Elizabeth is recorded as continuing to run the pub with her daughters and nieces. Local stories suggest that he killed himself in the building. When Jack and Hannah moved to the pub there was a little room walled up on the top floor. When they broke through into the room it contained an old bedstead. None of the locals could ever be persuaded to enter the mysterious room!

There is yet another story concerning a different lady who wanders up and down the stairs. She is said to be looking for her little girl who is being kept against her will in the dining room. They are trying to find each other but for some reason are never reunited. In the bar area between the stairs and the dining room doors are known to open and close on their own late at night or in the early hours of the morning when there is no-one there. A few nights before I visited the dining room door had been wedged open behind one of the tables. Hannah clearly saw the table move to release the door which then closed.

Residents staying in the Purple Room above the butcher's shop have experienced disturbed nights. One lady staying in there was convinced somebody was trying to strangle her in the night. If you choose to spend a night in this room look out for the lady who sits in the window. Something is stopping her from looking directly at the church but fortunately there is a monk on hand who is trying to help her.

CRAVEN ARMS

SUN INN
Corfton
Craven Arms
SY7 9DF

The Sun Inn is a rural family run village pub serving real ales and locally sourced, home cooked food. This friendly local pub is situated in the picturesque Corvdale between Ludlow and Much Wenlock. First licensed in 1613, the Sun Inn would have served the important crossroads for travellers to and from Wales and pilgrims to the great religious houses such as Wenlock Priory. It is also the home of the Corvedale Brewery. Established in 1997, a range of real ales are brewed on the premises here which can all be sampled in the pub.

Landlord, Norman Pearce, told me the story linked with the haunting here and an unexpected connection with Australia. In 1762 Margaret and David Jones had a daughter in the little cottage immediately behind the pub. The little girl was christened Mary but was later to be better known as Molly. Molly had worked at the inn but probably not as a barmaid. Given later events she may have been employed in some role which would have given her access to linen which was a valuable commodity in those days.

By 1785 the somewhat headstrong Molly, who had already had a child out of wedlock by another man, married a William Morgan. Molly and William were accused of stealing linen worth more than two shillings from the Sun Inn. The amount was significant given the harsh penalties of the day. William managed to escape arrest but the unfortunate Molly was taken back to the Sun Inn and locked in the cellar *en route* to Shrewsbury Assizes. For stealing linen worth more than two shillings she would surely have ended her days on the gallows at the end of a rope. Knowing this Molly chose to take her own life by slashing her wrists. This should have been the end of the story except for the intervention of the local surgeon. Molly was taken upstairs to one of the bedrooms and her gashed wrists successfully sewn back up. She was then locked up in the room until eventually being taken to Shrewsbury for trial.

In an uncharacteristic display of leniency the magistrate sentenced Molly to be transported to Australia for fourteen years. She seems to have survived the dreadful conditions aboard the prison ship by forming various liaisons with the crew in exchange for a more comfortable passage. From then on she led an adventurous life, escaping back to England on one occasion only to be deported again. She ended up back in Australia in the Hunter Valley area where Molly Morgan became well known for her infamous drinking and sexual exploits. However, by the time she died in 1835 aged seventy-three, she had become something of a respected figure and was affectionately known as 'The Queen of Hunter Valley'. In fact, her name lives on in the Molly Morgan Vineyard and Molly Morgan Motor Inn.

Coming up to date, ghostly figures are seen in the pub and the previous landlord used to see the apparition of a young woman. His bedroom was allegedly the same room that Molly Morgan was locked up in and he used to have a recurring experience there. On many occasions he would find himself locked in, the door having being bolted from the outside. His only means of escape when this happened was to climb out of the bedroom window. According to Norman, 'He always believed it was the ghost that did it.'

The bar is the older part of the pub and it is here that the girlfriend of Norman's son gets the distinct feeling that someone is watching her when she helps out in there. She has also seen shadows flitting by when there is no-one there. When a friend of Norman's wife stayed at the pub she came down on her own to help out with a bit of

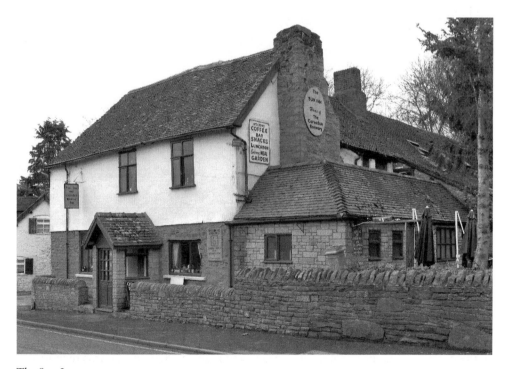

The Sun Inn.

cleaning. She soon fled back upstairs screaming that she had seen someone come in through the locked door and disappear through the wall. What she didn't know at the time was that where the figure disappeared through the wall used to be the old cellar door before it was blocked up and a new door put in some years before.

THE SWAN
Aston Munslow
Craven Arms
SY7 9ER

The Swan at Aston Munslow is a real old country pub. The building itself is mainly built of white painted stone with black and white half-timbered gables. Dating back to the 1350s, this makes it one of the oldest hostelries in Shropshire. The property was certainly recorded as licensed in the seventeenth century and was also known as the Hundred House, suggesting an earlier connection with the local administration of the area.

An intriguing and enduring tale associated with The Swan concerns a visit by the young Dick Turpin, who is said to have stayed at the pub as a boy. He turned up one

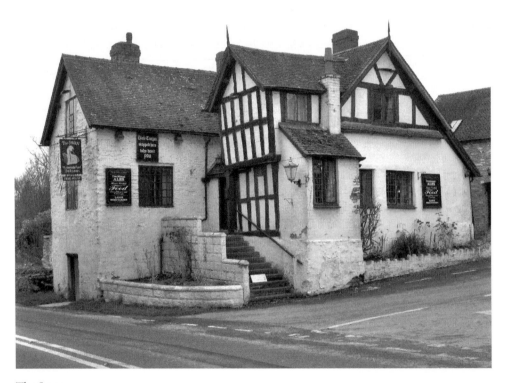

The Swan.

day having hitched a ride on a brewer's dray to the remote village of Aston Munslow. His father was a butcher and the story goes that the young Dick Turpin was apprenticed to a local butcher when he was around twelve years old. His now legendary life of crime began as a young man when he joined a gang of poachers and ended in 1739 when he was hanged at York for horse theft. The story of Dick Turpin as the dashing highwayman is very much down to Victorian author, William Harrison Ainsworth.

Despite his notoriety and slow strangulation at the end of a hangman's rope, it seems it is not Dick Turpin who haunts The Swan. It is the apparition of a lady who is seen in the pub and often briefly observed going up the stairs. There is never anyone up there when this happens and according to landlord Malcolm Williams, 'I've definitely thought I've seen somebody going upstairs but there's nobody there.'

In common with many of the other pubs in this book, The Swan is also subject to low level poltergeist activity. The gas taps in the cellar are prone to getting turned off even though Malcolm himself is the only person who looks after the beers. As Malcolm says, 'there's no reason for the taps getting turned off because it's only me who ever goes down there'.

IRONBRIDGE GORGE

ALL NATIONS INN

20 Coalport Road
Madeley
Telford
TF7 5DP

The All Nations Inn is a friendly, traditional home brew pub which was first licensed in 1832 as a consequence of Wellington's 1830 Beerhouse Act. The pub is situated on the old Coalport Road opposite the entrance to Blists Hill Victorian Town Museum. The building was originally built and owned by the local Baguley family and dates back to 1789, as can be seen from the date stone above the window over the front door. The slightly unusual name is thought to stem from the practice of collecting unburnt tobacco in a jar and selling it as 'All Nations'. Real ale is still brewed behind the pub and the All Nations was awarded Telford and Shropshire Pub of the Year by CAMRA for years 2010 and 2011.

Concerning the ghostly goings on in the pub, Landlord Jim Birtwhistle had this to say:

One of the cleaners we had used to say that when she came in there was always somebody sitting here to the left hand side of the fireplace. He was a smallish person with a woolly hat and fingerless mittens. She used to sweep around him when it should have been just her in the bar and she's absolutely convinced he was there – it isn't as if she used to hit the spirits! She talked to some of the older customers in here because this was about nine years ago when she used to clean for us, when we first started. They said it sounded very much like this particular old chap who used to come in the pub regularly before he passed away. Apparently he always wore his woolly hat and fingerless mittens.

According to Jim the All Nations is very dog friendly:

There must have been hundreds of dogs in here over the years and the presence of one of them is felt in the bar. A lady came in who does a show for a local radio station and

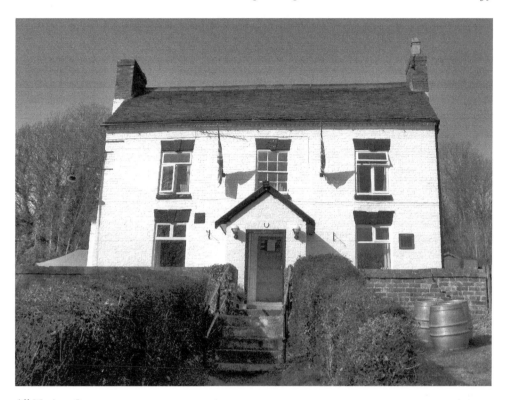

All Nations Inn.

the moment she came into the bar she felt a presence here. I asked if it was male or female but she said it was definitely a dog's presence.

So, don't be too surprised if you are standing at the bar and feel a dog brush past your legs. It may belong to one of the friendly locals of course or you may have just been welcomed to the pub by its resident ghostly hound.

BIRD IN HAND INN 1774
Waterloo Street
Ironbridge
Telford
TF8 7HG

The Bird in Hand has been an inn since it was built in 1774, five years before the famous Iron Bridge over the River Severn was constructed in 1799. Now, as then, this family run inn offers comfortable accommodation overlooking the river and serves home cooked food and a range of real ales. The traditionally styled dining room with its inglenook fireplace and extensive beams has been tastefully restored and it is here that the inn's ghost has been seen.

Barman, Mick Edwards, told me the story of the ghost which was widely reported at the time. It concerns two elderly couples who were travelling back to London from Shrewsbury. They stopped off for a meal and sat at the table to the right of the inglenook fireplace in the dining room. After the meal when they were ready to pay, Mick asked them if everything had been okay. The one old gentleman commented on how good the meal had been but the other gentleman said, 'You know this place is haunted don't you? He's a friendly ghost and his name is Henry. He actually sat with us while we were having our meal. He's only got one arm and he lost it helping to erect the Iron Bridge. He always sits in the dining room, up the corner.'

Later that night Mick locked up as usual but on his way out noticed a light was still on inside. He went back in and it turned out to be one of the spotlights above the notice board. When he switched it off the bulb exploded. Not too unusual in itself except that the glass from the bulb which should have shattered all over the floor was never found. Even stranger, the following night a bulb in the cellar exploded and again no glass was ever found. As Mick commented, 'Not only a friendly ghost but a bloody tidy one!' A similar thing happened with a sprinkler off the beer pull, 'I've dropped the sprinkler off the beer pull, seen it hit the floor and we've never found it! I saw it hit the floor, went to pick it up and it just disappeared, same as the glass out of the bulbs.'

Even before all this, Mick had an unusual experience in the cellar. 'I was downstairs [in the cellar]. I go down at the beginning of every shift to get the ice cubes and I was leaning over the freezer. I felt like somebody was touching me or tapping me on my left hand shoulder. Of course I turned around and there was nothing there.'

Shortly before my visit Mick had experienced even more poltergeist type activity:

About three weeks ago I had got all the glasses off at about this time [6.00 p.m.], cleaning the shelves and the doorbell rang. I went out and there was nobody there. I noticed the security lights hadn't come on so I walked back in. As I got to the door there was such a crash behind the bar and I thought somebody had run in so I ran into the kitchen but the outside door was still locked from the inside. What had happened, for some reason, four cans of Guinness and two bottles of Magners had come off the shelves and were on the floor behind the bar. There was just no way could they fall off. I mean it just doesn't happen. All I have to say when these things start happening is, 'Henry sod off!' and peace is restored.

After the events in the dining room Mick and his wife were in the pub one Sunday lunchtime and Mick happened to look across to the photographs of bridges above the fireplace in the dining room. Mick noticed that from a certain angle the bottom right hand picture takes on the image of a man's face. Yet another picture in the lounge appears to have the image of a man's arm coming out of a chimney. If you visit the Bird in Hand be sure to have a look at these pictures. Take care if you have a full pint of beer though as Henry is apt to knock it over whilst you look at his picture!

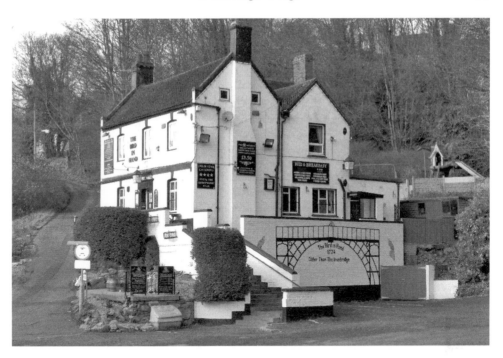

Bird in Hand Inn 1774.

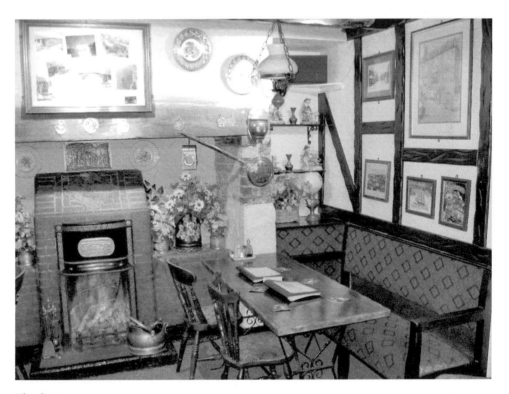

The dining room.

BUILDWAS ABBEY SPORTS AND SOCIAL CLUB
Wenlock Road
Buildwas
Telford
TF8 7BP

Buildwas Abbey Sports and Social Club is housed in the beautiful old abbot's house at Buildwas Abbey. Dating back to 1135, for most of its life Buildwas was a substantial abbey of the Cistercian Order. During the Dissolution of the Monasteries under Henry VIII, the abbey found itself converted to a Tudor mansion in 1536. The Abbey Club itself is a private members' club, although the abbey ruins are in the care of English Heritage and open to the public. However, non-members are welcome to visit the Abbey Club building providing they sign in and pay a nominal 50p.

Being relatively close to the Welsh border the abbey was caught up in the Welsh revolt led by Owain Glyndŵr between 1400 and 1409 before it was eventually suppressed by Prince Henry, later Henry V. The abbey was subject to numerous raids over this time and in 1406 a group of raiders even kidnapped the abbot. An event which occurred earlier in 1342 has given rise to the story of the haunting of the Abbey Club and also the area around the abbey ruins and nearby Buildwas Power Station.

Steward of the club, Gaye Pope, explained that the building is haunted by the ghost of a past head abbot who was murdered at the abbey. He is locally known as George but historical records fail to confirm a name for the unfortunate victim. He was murdered by one, or possibly more, of his own monks. His ghost is said to wander the Abbey Club, the ruins and the nearby Buildwas Power Station continually seeking revenge on his attackers.

There is a historical context for this as in 1342 the head abbot at the time was murdered by one of the monks, Thomas Tong, possibly with help from other monks. Records show that he not only got away with the murder but was brazen enough to seek re-admission to the Cistercian order. As if that was not bad enough, the sudden loss of the abbot caused the fortunes of the abbey to fall into a decline as disputes raged over who should be the new abbot, and valuable resources were squandered away by the monks. Reason enough, perhaps, for the vengeful spirit of the dead abbot to want his revenge on those responsible.

Over the years there have been many sightings of the Black Monk in and around Buildwas Abbey and the social club itself. Even workers at nearby Buildwas Power Station have been shaken by seeing the figure of the Black Monk disappear right in front of them. It tends to be men who actually catch sight of the vengeful Black Monk, which may be due to his search for his own murderers.

Experiences in the social club are by no means exclusive to men though. Gaye explained that there are parts of the building where people simply don't like going:

> The girls all hate the upstairs ladies' loo. It's time warped, you just imagine that somebody like Marilyn Monroe's going to walk in. We did a Mr & Mrs event here this week and that was the only place where they [wives] couldn't hear the microphone,

so we had to take them up there while their other halves were asked questions. They were going up in fours; they wouldn't go up there by themselves! There's a horrible feeling there, the girls don't like this room at all.

Up in the attic is a room thought to have once been the abbot's bedroom. It has an archaic pulley operated toilet system but these days the only things that sleep up there are a colony of protected bats. There is a room a little further on which Gaye can't stand to enter. Its former purpose is lost to time but the walls are painted pink suggesting it may have been a child's bedroom at some point in its history. On entering this room there was very marked temperature drop compared with the rest of the building. It was quite chilling. Gaye finds the room to be, 'just horrible. I can't stand this room. It spooks me'.

The other area where people have strange feelings is the snooker room on the ground floor. In the days when the building was a residence the area now housing the snooker table used to be used for hanging meats. Whether the strange, unnerving feelings experienced in this room are due to the presence of the Black Monk or another ghost residing in the building is not known. The presence felt here may be that of an unfortunate woman who met a violent end in the cellar here at the hands of an unknown murderer.

Buildwas Abbey Sports and Social Club.

THE BOAT INN
209 Ferry Road
Jackfield
Telford
TF8 7LS

The Boat is a traditional riverside inn, now one of only three pubs left in Jackfield, serving a range of real ales and freshly prepared food including a Sunday carvery. Famously known as 'the inn that floods', or 'the boat that never sinks', a board on one of the doors displays record flood levels from over the years. The inn was licensed in 1840 but it is thought to have been operating as a brew house long before this date. It is difficult to date the actual building as a fireplace and some of the timbers go right back to Tudor times.

The pub is subject to a great deal of current paranormal activity but also has a traditional tale associated with it. One Sunday the Devil decided to go and play cards with locals in The Boat Inn, presumably to try and win their souls. When a card fell to the floor the Devil's cloven hoof was seen and he was discovered for who he is. At this the Devil leaves in a great gust of wind and the locals escape with their souls intact.

Jenny Alexander and Alan Cambridge of The Boat Inn are adamant that the presences here are all benevolent and not at all malicious. In the early 1960s the landlord at the time had a daughter named Vicky who very tragically died of Leukaemia in her early twenties. She always appears in the same place at the top of the stairs to the living quarters and generally only to younger, male members of staff. Alan described one lad's experience of Vicky:

> When she first appeared it frightened one of the young lads and he described her as a youngish girl in old fashioned clothes so we naturally assumed it would be Victoriana but what he meant was '60s clothes which to him was old fashioned!

Upstairs the present living accommodation was once a series of bedrooms and both Alan and Jenny have experienced auditory phenomena there. They have both heard what sounds like someone getting up from an old fashioned bed. Alan describes the experience:

> About six o'clock in the morning there's a distinct noise of an old fashioned bed, the old iron cots with the springs. Somebody getting out of bed wearily and putting on a big pair of boots with lots of sighs. I think it's an old man getting out of bed to go to work. I haven't heard that for quite some time now but that was regular every day for at least a month.

Jenny has also heard children singing on occasions and indistinct mumbling, like people chatting. Particularly around Christmas time she has heard what sounds like children running excitedly up and down the long corridor in the living quarters. The spare bedroom is also susceptible to paranormal activity:

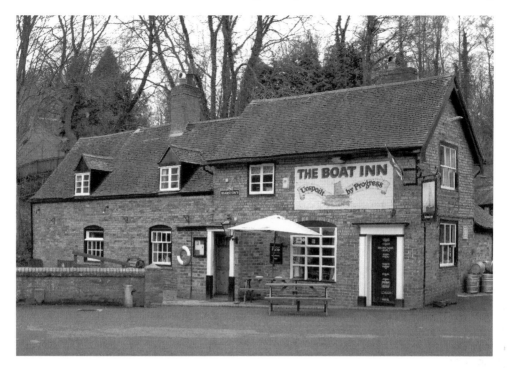

The Boat Inn.

We've had friends and family staying in the spare bedroom at the end and there's been some experiences there. Firstly one of our friends, who actually lives in the village, occasionally looks after the place when we're away. He was staying in that end room and was awoken one night with the distinct impression that there was an old woman looking at him from the end of the bed. It was indistinct. It was like a grey sort of fuzz but he got the distinct impression it was a woman, an old woman but again not malicious, just sort of looking. When my [Alan's] brother-in-law and sister-in-law were staying from America they were using that room and they got the impression of somebody sitting on the end of the bed, again they thought it was an old woman but couldn't see clearly, but that was the distinct impression.

There have also been tactile experiences downstairs in the pub itself. When Alan has been in the food preparation room at the back, which was the old kitchen, he has frequently had the feeling that someone has just brushed past and on occasions felt a friendly shove as if someone was trying to move him out of the way. Customers have had very similar experiences at the bar by the doorway to the carvery restaurant. People standing there have been shoved out of the way on numerous occasions but no-one ever sees who has just pushed past.

On sunny days the garden by the river is a popular spot for customers to congregate. People dressed in Victorian clothes have been seen here around twilight time and the natural assumption is that they must be costumed guides from nearby Blists Hill

Victorian Town. That is until someone goes over to talk to them and they simply aren't there anymore, even though no-one ever sees them leave.

THE COALBROOKDALE INN
12 Wellington Road
Coalbrookdale
TF8 7DX

The Coalbrookdale Inn is an early Victorian Grade II listed building. It is a family and dog friendly pub which prides itself on the range of well-kept real ales served here. Tourists and locals alike are sure to get a warm welcome as was the case on the day I visited. The building was owned by a boot and shoe maker, John Bailey, who took advantage of Wellington's Beerhouse act to open a single room pub in 1834 on payment of two guineas. By 1851 the pub had been granted inn status and as such could remain open as long as there was a bed free, basic food available and homebrewed ales.

Manager Louise McManus and her partner Gavin Wright only moved into the pub in January 2012, but it wasn't long before the ghostly residents began to make themselves known. They had only been in the property a week when Louise had her first experience:

> I've heard about a soldier. It would be conjecture on my part to say it's definitely him but in the first week that I was here there was only me in the pub, all the doors were locked. I heard someone very clearly walking around upstairs. So clearly to the point that I thought, 'did I lock someone in the toilet last night and they've actually got up into our living quarters?' So, I went up and there was absolutely no-one there. I've heard that a few times now actually and the strange thing is it's always in the daytime.

Louise was told by regulars that many years ago there used to be card games upstairs once the pub had closed. The layout has changed now but at the time there was another room upstairs where a corridor and office is now. Quite often, the card players would see a figure leaning nonchalantly in the doorway just watching them. It happened so often that they just got used to it. Possibly this is the figure Louise has heard walking around upstairs.

Gavin does a good deal of the cellar work and both he and Louise on a number of occasions have seen what looks like a little boy peeping around the bottom corner of the cellar steps. They just catch a quick glimpse of him when going down into the cellar, but when they look again he's not there. Whoever he is, he seems to be a happy little chap who likes to play tricks, as Louise explains:

> I've gone down the cellar, switched all the beers on and I know I've switched all the beers on. I've turned on the taps and everything and then nothing's coming through. A particular one will have been turned off again and there's only me been in the cellar.

The Coalbrookdale Inn.

The cellar steps.

That's happened a good few times now. The thing about everything here is that I wouldn't perceive any malice; it's just naughty things more than anything. This might sound a bit daft, but we make a point now of going down and saying hello I'm back or similar – I think it's best to keep people on side!

Activity in this area doesn't seem to be restricted to the inn itself either. A few weeks before I visited they had suffered a power cut on quiz night. During the blackout Louise walked down to the traffic lights to try and see how extensive the power cut was:

On the other side of the road by the old church, there was a lady looking at me. Quite small, stooped, quite long clothing and she was staring across. When I looked away and back she wasn't there at all.

There have been reports in Coalbrookdale of an old lady, said to be a long gone member of the Darby family, who walks around the area at night. Perhaps this was the figure seen by Louise who wouldn't have known anything about the old lady at the time of her sighting.

THE GROVE INN
10 Wellington Road
Coalbrookdale
Ironbridge
Telford
TF8 7DX

The Grove Inn was up for sale at the time of writing. It is situated immediately opposite The Coalbrookdale Inn which is also featured in this book and close to the Museum of Iron. Quaker families were central to the development of the iron industry in Coalbrookdale. Indeed, Abraham Darby, grandfather to the builder of the famous Iron Bridge, established a works at Coalbrookdale in 1708. Abraham Darby II set aside land for a small Quaker burial ground in Coalbrookdale which can still be visited today.

The strong Quaker association with Coalbrookdale is connected with one of the ghosts that haunt The Grove Inn. Gaye Pope used to be the landlady of The Grove. She and many other people saw the apparition on many occasions both during the day and at night. Gaye described him as having 'a big Quaker hat and a long coat almost to the ground'. The figure was seen so often that he was affectionately named Percy. Unfortunately, beyond the obvious Quaker connections with the area, there is no other clue as to who Percy was or indeed why he should be haunting The Grove Inn. Gaye explained that he wasn't seen as a solid figure but 'transparent, you've got the contours and you've got the shape and you can see he's a Quaker'. Until she got used to seeing him around the pub Percy could be somewhat frightening at times. According to Gaye, 'If I turned round and he was behind he would drift right through me. Very, very bizarre.'

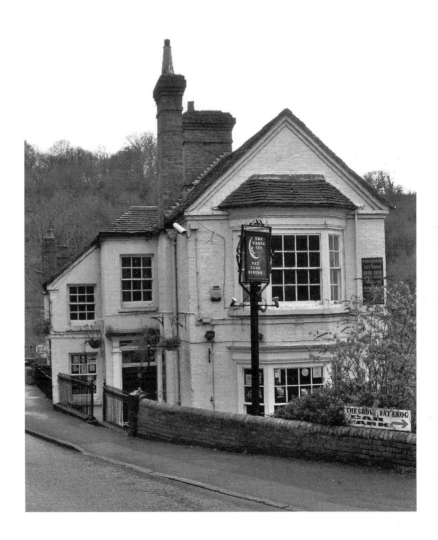

The Grove
Inn.

By pure coincidence when I was gathering the stories from The Coalbrookdale Inn immediately opposite, Kev, a long-time customer of The Grove, was able to confirm what Gaye had said and provide even more details on the haunting of the pub. According to Kev you could always tell when Percy was about in the pub because of the intense chill that accompanied him even if the heating was turned fully up in winter. Kev described his experiences of seeing Percy on a number of occasions:

You couldn't see exactly what he looked like, but you could see his shadow and the hat. Then all of a sudden he'd be gone. No end of people would say 'something's just gone past the window' yet there was never anybody there.

Percy also used to make his presence felt when the pub was being renovated as Kev explains:

> With any alterations going on Percy would come and show himself and you just took no notice and got on with what you were doing. You always knew if Percy was about because it would go cold but I always used to say, 'Come on Percy, go away and leave us alone!' Before it was renovated we were all standing at the bar and all of a sudden a pint glass just lifted off the shelf and went across the room with nobody anywhere near it. When they were renovating there was a marquee at the back for the locals to use. There was snow on the ground at the time and the heaters were on full. We were all sitting in there and my dad, who was behind the bar said, 'there's an ashtray moving on that table down there'. Nobody was sitting near it and we were all looking. The ashtray was just moving around the table on its own. We thought surely Percy hasn't followed us out here!

When the Grove had bed and breakfast accommodation some of the residents would have disturbed nights due to a child crying even though there were no young children in the building. One guest even awoke in the early hours to see the apparition of a child staring at him from the foot of the bed. The upstairs rooms were often noisy according to Kev:

> You could plainly hear footsteps. Plain as anything these footsteps were, and you would go up thinking someone had got in and search the rooms but nothing. Then you would go back downstairs and you could hear it again!

On one occasion, as one of the regulars was saying goodnight to the bar staff, the handle on the front room door started to slowly turn. The door opened as they all watched and then suddenly slammed shut. There was no-one in the front room at the time.

THE MINERS ARMS
74 Prince Street
Madeley
Telford
TF7 4DY

The Miners Arms is a traditional local pub first licensed in 1851, most likely as a result of Wellington's Beerhouse Act of 1830. As the name suggests the pub serves as a reminder of the long-gone coal mining industry in the area. The pub of today appears to have been created by knocking some older cottages together to form one larger building.

At the time of visiting, one of the locals was able to tell me about an old gentleman who used to watch *Match of the Day* every Saturday night. He always sat in one

particular seat and watched the television in the area to the left of the main bar. On this one occasion the pub was fairly quiet and the barmaid at the time was standing behind the bar. She watched the old gentleman get up to go to the toilet. As he walked towards the gents a short figure in a flat cap came through the wall immediately behind him and followed him right through to the gents, much to the amazement of the barmaid. Examination of the area where the figure came through the wall still shows evidence of a long bricked up doorway from one of the original cottages. It seems likely that this particular apparition, whoever he is, is associated with the earlier cottage rather than the pub itself.

Another regular was able to tell me that all sorts of paranormal activity had occurred in The Miners Arms over the years. The present landlord had only taken over the week before I visited but previous landlords and landladies have experienced doors opening and closing on their own at the rear of the building when there has been no one in that area. They have also had the experience of locking up the pub for the night and retiring to bed only to hear the bar come to life again with the sounds of people talking and enjoying themselves. Invariably they would come back down to see what was going on and thinking that people must have gained entry to the pub, only to find a sudden silence, and of course, no-one there.

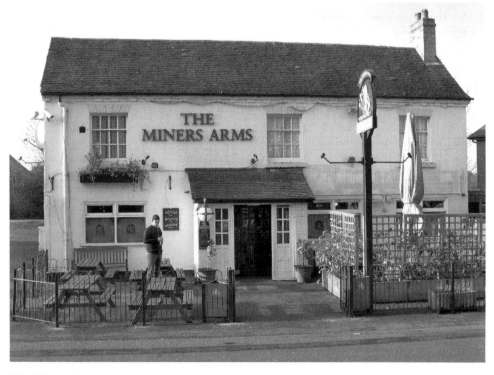

The Miners Arms.

THE TONTINE HOTEL
The Square
Ironbridge
TF8 7AL

The Tontine is a family run hotel with twelve comfortable rooms, a restaurant, a carvery and an extensive bar menu. It was originally constructed to give visitors unparalleled views of the famous Iron Bridge which it does to this day. The Tontine was opened in 1784 and was constructed by a consortium of business people which included members of the Darby family and others involved in the erection of the Iron Bridge itself. The name 'Tontine' derives from the method they chose to fund the venture. Each investor would continue to receive an annuity whilst they remained alive. Upon death, the remaining investors would benefit from an increased return on their investment until the last surviving member would inherit everything.

Former landlady, Trish Gentleman, spent many years at the Tontine after moving there in 1991. As soon as they arrived they were made aware of strange happenings in Room 5. It was in Room 5 in 1950 that Frank Griffin, a forty-year-old hotel worker, was arrested for the murder of seventy-four-year-old Jane Edge. She was the landlady of the Queen's Head Hotel in Ketley. Frank had apparently been drinking and she offered to go and make him a cup of tea. When she returned she found him stealing money from the till. Griffin pleaded at the trial that he had only pushed the landlady away but she fell badly and was killed. He fled to The Tontine Hotel and spent a few days hiding out in Room 5 before finally being arrested there. As Trish says, 'You can imagine what he must have felt like in that room. If he was caught he would be sent for trial and he would be hung which is exactly what did happen.' According to an *Express & Star* newspaper report of the time, Frank kept repeating Jane Edge's dying words at his trial, 'The money won't do you any good, my lad.' And, indeed, it didn't, as Frank Griffin was hanged at Shrewsbury Prison on the morning of 4 January 1951.

Since then, people staying in Room 5 have experienced feelings of intense cold, the taps have been known to turn themselves on in the night and people have felt a presence there. One really strange phenomena attributed to Room 5 is that clocks have been known to run backwards, almost as if Frank Griffin was trying to buy himself more time before his inevitable date with Albert Pierrepoint, his executioner.

Very recently, a structural engineer who was working in the area was booked into Room 5. He knew nothing of the stories but later the same evening came downstairs and requested a room change as he said he felt there was a disturbing 'presence' in the room and he didn't like it. At the time the hotel was full so he reluctantly stayed in Room 5. The following night he came down and handed his key in saying that if he couldn't be found another room he was prepared to go and sleep in his car! He had been in bed and awoke to feel as though something was trying to strangle him. Unbeknownst to the engineer at the time he was not the only one to have felt this in Room 5.

A workman doing some maintenance in Room 5 had got a lead lamp and an electric drill both plugged into a double socket. He said later that the room suddenly went icy cold and the lamp went out but the drill continued working. He had an overwhelming

feeling of fear and had to leave the room immediately. He refused to go back in and a work colleague even had to go and retrieve his cigarettes for him! When the lamp was tested later there was nothing wrong with it.

Trish remembers an experience a visiting taxi driver had:

A taxi driver from London stopped in the room and felt slightly uneasy. He'd attempted to video the interior of the room and immediately had problems; the picture was distorted in one of the corners of the room. He had no problems with his video elsewhere in the hotel it was just in this one particular corner and I saw the results and you had to see it really – it was weird – distorted, but only in one spot.

The Tontine Hotel was the only establishment I visited whilst researching for this book where something slightly odd happened to me whilst collecting the stories:

While I was at the hotel I was able to photograph the principal rooms involved. We started in Room 5 and as it happened Trish had forgotten to bring the keys for the other rooms. The room was pleasantly warm even though it was February because the central heating was on. As I was taking pictures in Room 5 I stood partially in the doorway to the bathroom. The door was open and I noticed how freezing cold the bathroom was. At the time I remember putting this down to the time of year and the water pipes running through it. Having taken another couple of pictures from different positions in the room I decided to try and get a wider angle view from the bathroom door again. There could have been no more than a couple of minutes between the shots but the temperature in the bathroom now felt pleasantly warm, exactly like the rest of the room. Nothing had changed, no doors or windows had been opened or closed but the intense feeling of icy cold was now replaced by the pleasant warmth you would expect in a comfortable hotel bedroom.

Room 5 is not the only bedroom to have strange things happening. Room 2 is a twin-bedded room which for a time was occupied by a father and son working locally as Trish relates:

They'd been staying in room 2 for a number of weeks. They were contracted to the Power Station and one night when they'd gone up to bed something woke the son up and he saw what he thought was his father walking towards the wardrobe and he said, 'What's the matter dad, can't you sleep?' and his dad didn't answer but continued to walk straight through the wall. When he looked in the other bed his dad was asleep, fast asleep. The fact is the corner of the room where the wardrobe is situated originally did have a door there; it was an inter-connecting door to the next room which is no longer there. Although there's a wardrobe in the corner the doors had been sealed off but the figure walked through the door. He [the son] was quite shaken up.

An American guest staying in Room 4 swore that as he was getting into bed the room went icy cold and he felt somebody sit down on the end of his bed. He couldn't see

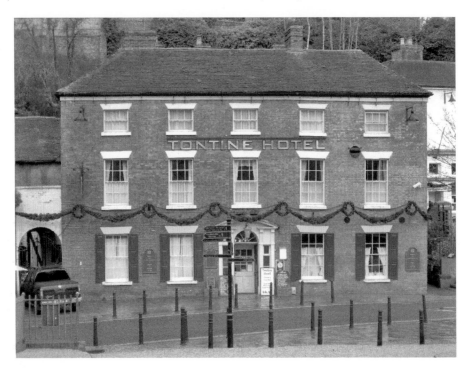

The Tontine Hotel.

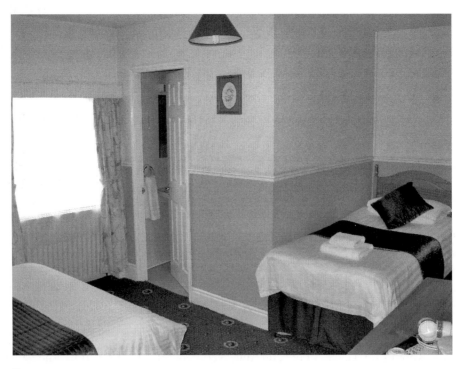

Room 5.

anyone except the clear indentation of somebody sitting there. He was so unnerved by this he went and spent the night with a travelling companion staying in another room.

Things are also experienced in and around Room 9 according to Trish:

Footsteps have been heard walking down the corridor towards Room 9 – but it's carpeted! It's not till much later do you query 'well how can I possibly have heard footsteps on a carpet?' You just wouldn't but other people have said the same. There are stories of a servant hanging themselves in Room 9 which may account for the unpleasant feelings people have experienced in here.

Staff have had repeated experiences here. Kitchen staff are frequently tapped on the shoulder when they come in for the first shift of the morning. It is a definite, firm tap but when they turn around there is never anyone there. When she has been alone in the bar Trish has clearly heard a sound like a glass being tapped as if someone was wanting a drink and her name being called. At one time the bar would close between 3 p.m. and 7 p.m. on a Sunday. Staff doing a double shift would sometimes go upstairs for a bath or to wash their hair. One younger member of staff who went upstairs between shifts for a bath came down later complaining bitterly that someone had been turning the handle of the locked bathroom door. At the time he just assumed someone was trying to frighten him and they may have succeeded as the rest of the staff assured him he had been alone up there the whole time.

There are reports of the ghost of a little girl haunting The Tontine. When Trish first moved in they lived in the large flat on the premises and would keep finding marbles in there. After clearing them away the marbles would return a couple of days later. At the time Trish thought it was a child and subsequent events seemed to confirm this:

In Room 11 we had a family come to stay. The woman apparently is psychic and she said she was awoken by a child crying and she thought it was one of her own children (there was mom and dad and two girls) and she thought it was her younger daughter. So, she called out to her daughter which immediately woke her up and the little girl said, 'Mommy there's a little girl sitting on the end of your bed, why is she crying?' and that's when the mother said just come and sit next to me. Apparently the mother said that the little girl was crying because she was afraid of the dog. So there was a dog somewhere but they got the little girl's name, Heather. She was eight years old and they described her as wearing a long dress with like a smocked front and the mother spoke to me about it but then the little girl also told me about it but she didn't use her mother's words. She told me exactly what she saw and that's very rare for people to see something at the same time. That was the one room, Room 11, that I thought was not haunted and two people see it!

That was not the end of the matter, however. A group of student doctors and nurses booked Room 5 for a charity ghost hunting event around Hallowe'en time. They stayed up all night and did have some experiences such as the bathroom light turning itself on

and a picture on the wall flying off. When they came down for breakfast the following morning they were very apologetic. They had left the television on all night and said they had upset one of the other guests. Apparently they heard the sound of a little girl crying and had naturally assumed they had woken her up with the noise they had been making. They were telling the breakfast chef in the morning and he told them, 'We didn't have any other residents but yourselves in last night.'

WHITE HART
10 Wharfage
Ironbridge
Telford
TF8 7AW

The White Hart is an eighteenth-century riverside coaching inn offering newly refurbished accommodation along with dining rooms, bar and a continental style courtyard. The pub predates the Iron Bridge itself by some years and given its close proximity would have been popular with the original bridge builders.

There have been stories about ghosts at the White Hart for many years but in early January 2011 things came to a sudden head, literally, as General Manager Mike Hibbert explained. Housekeeper, Sharon Thompson, was cleaning one morning and she called Mike over to look at a strange face which had appeared on one of the windows. It had definitely not been there the previous night when the pub was shut up and it was first thing in the morning when Sharon instantly noticed it:

> The actual facial features with the exception of the chin were very small, almost childlike, and yet it had this great big chin. You could even see the eye sockets. It was just so weird and a big nose like that you wouldn't get as a child. The actual features were really small.

The face that had suddenly appeared on the inside window remained there for nearly three weeks until an unsuspecting window cleaner removed it! During that time it defied all attempts to recreate it and no explanation for how it got there could be found.

As to the identity of the strange face, one theory was put forward by someone who had seen the picture in a local newspaper. He thought that the face bore a striking resemblance to a Cornishman, Richard Trevithick. Intriguingly, he was known to have been in Ironbridge during 1802 whilst the Coalbrookdale Ironworks was building a high pressure steam engine to Trevithick's newly patented design. It is believed he certainly visited the White Hart and may even have stayed at the inn.

The face on the window is just one of the unusual things going on in the pub. Sharon often has the feeling that she is being watched. 'You always feel like someone's watching you or you think somebody's in the office which is opposite one of the rooms and I think Mike's up there. I've turned around and there's nobody there.'

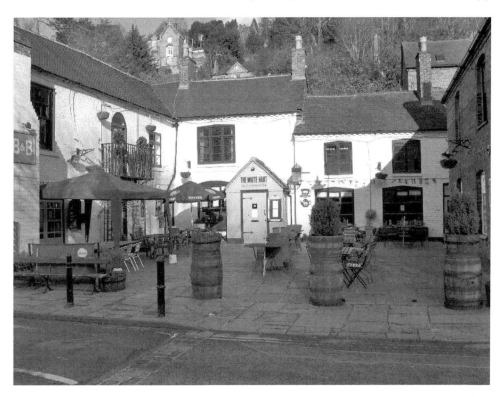

White Hart.

The ghostly face.

According to Mike they are always hearing odd noises in the building such as loud creaks and doors banging inexplicably. Sometimes there will be a knocking on the door as if someone is trying to get in but when they go and look no-one is there. On one occasion a member of staff put their cigarette lighter in a wine glass at the rear of the bar. Halfway through the evening the lighter came flying over the bar as if it had been thrown. When they looked, the glass it flew out of hadn't even moved.

Sharon told me that guests staying at the White Hart sometimes experience the ghostly activity here but don't even realise it until they come down for breakfast or to check out. Mike gave an instance that occurred later on in 2011:

> We have five lovely *en suite* bedrooms upstairs and a couple came down in the morning. I cooked them breakfast and I said, 'Good morning, how are you, did you sleep well?' and she said, 'No, I didn't sleep at all well.' I said, 'Oh why was that?' She said, 'It was the noise, people walking along the corridor all night kept me awake.' I said, 'I hate to have to tell you this but you were the only people staying here last night!'

KYNNERSLEY ARMS
Leighton
Shrewsbury
SY5 6RN

The Kynnersley Arms was closed at the time of visiting. This Grade-II listed building is probably unique in containing both the remains of a mill and one of the earliest blast furnaces in the Ironbridge area. The historical significance of the site can be judged by the investigation of the site by Channel 4's *Time Team* who uncovered the remains of a seventeenth-century blast furnace and bellows chamber in the cellar. At the height of the English Civil War cannon balls were made here and shipped off down the River Severn to Worcester. The water wheel to the side of the pub was grinding corn right up until the 1930s. A mill was listed as being worked on the site in the Domesday Book as early as 1086. After the *Time Team* excavation, landlady at the time, Jane Wood, put a glass panel in the pub so that visitors could look down at the extent of the industrial archaeology still remaining there.

Jane explained that it is no surprise that a building with such a long history has experienced its fair share of misery. Unmarried girls who fell pregnant and found themselves homeless would gather at the furnace for a little warmth. The girls that died there would be buried nearby in unconsecrated ground as even in death they would be denied burial in the churchyard. Jane recalled that some of the older locals would talk about a girl called Mary who met this particular fate. There was no concept of health and safety in those days and there must have been some terrible injuries suffered by the people who worked here over the years. With such emotion having being experienced here it is perhaps no wonder that the site is far from quiet.

When Jane and her partner first moved to the pub the older locals would tell tales of their experiences in the pub. One such old customer was the late Martin Gough. He

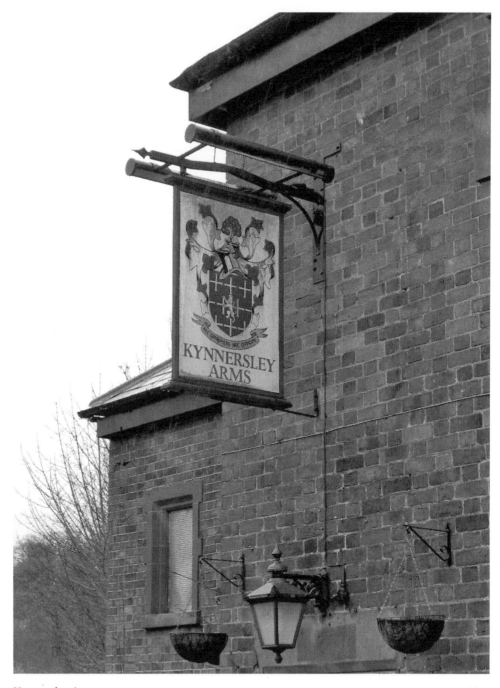

Kynnersley Arms.

had cause to stay in the Kynnersley Arms one night and vowed he would never ever stay there again. This was before the days of the glass viewing panel and was probably just as well, for the loud noises that disturbed him so much were coming from the long abandoned industrial workings directly beneath the bar. Martin's daughter, Teresa Sherwood, also had strange experiences here. As Jane recalls:

> Teresa a few times would say, 'something really weird has happened Jane' and I'd say, what's that? She'd say it sounded like a mop bucket scraping along the gent's toilet floor area which was immediately over the corn mill.

This would always be when there was no-one in there who could have made such a noise. On a number of occasions, Jane's partner Pierre would be in the beer cellar beneath the pool table area at the front of the pub and he would clearly hear footsteps walking around the room directly above him. This always happened when the pool table area was closed up and empty. When Pierre would go to look there would never be anybody there.

Jane had taken a delivery one day and left a box by the back door to be taken down into the cellar. Pierre was there with Teresa at the time and he heard a deep laugh as he went to pick the box up. Oddly, although Teresa was with him, she didn't hear the laugh but she did hear the strange scraping noise that she had heard before.

The bar area above the workings was also subject to poltergeist-type activity. Jane used to have a recurring experience, 'A lot of lights would come on at night downstairs in the bar. I would go down in the morning and I would know I had turned those lights off last night.' Jane also had the experience of some unseen force physically stopping her from walking across the landing upstairs. It was only momentary but a definite force stopped her in her tracks. This might be tied in with a certain room upstairs where children particularly have refused to sleep. A previous landlady had an even more direct experience of this poltergeist activity as Jane remembered:

> The previous Landlord and Landlady had the decorators in and the Landlord was at one end of the bar and she was at the other. She turned round and said, 'why did you do that?' He said, 'do what?' She said, 'pull my skirt so hard!' So much so that they got the decorators to paint ghosts on the Ladies and Gent's doors. I don't think they actually saw anything but they did feel it.

Hopefully, the Kynnersley Arms will one day once again welcome visitors to experience the heritage, and possibly even the haunting, of this uniquely historic building.

LUDLOW

BLUE BOAR
Blue Boar Inn
52 Mill Street
Ludlow
SY8 1BB

The Blue Boar Inn is a Grade-II listed traditional pub situated in the centre of Ludlow. The inn has long been associated with a veritable procession of ghosts inhabiting the building. Best known of these is an officer connected with nearby Ludlow Castle. He is said to be seen wearing a blue tunic with shiny silver buttons. Each floor of the Blue Boar seems to be haunted by a different apparition with a lady in Victorian dress and a man smoking a pipe inhabiting the upstairs rooms.

 According to one of the pub managers strange things often happen in the bar area. Mischievous poltergeist activity is often experienced here. If you visit this particular pub keep an eye on the clock near the front door. The hands have been known to spin round madly during periods of activity. Indeed, the front door itself which isn't supposed to open inwards will do so at times to allow some unseen presence to enter. Keep an eye on your pint glass though. You don't want it tipped over by some invisible hand!

CASTLE LODGE
Castle Square
Ludlow
SY8 1AY

Castle Lodge is a prominent Grade-II listed Tudor house situated right in the centre of historic Ludlow. Once used as a hotel it is no longer licensed or takes guests but is open every day for visitors to explore the extensive building even though it is now a private residence. In 1965, scenes for the film *Moll Flanders* were shot here and the interior boasts fine oak panelling and Tudor stained glass windows.

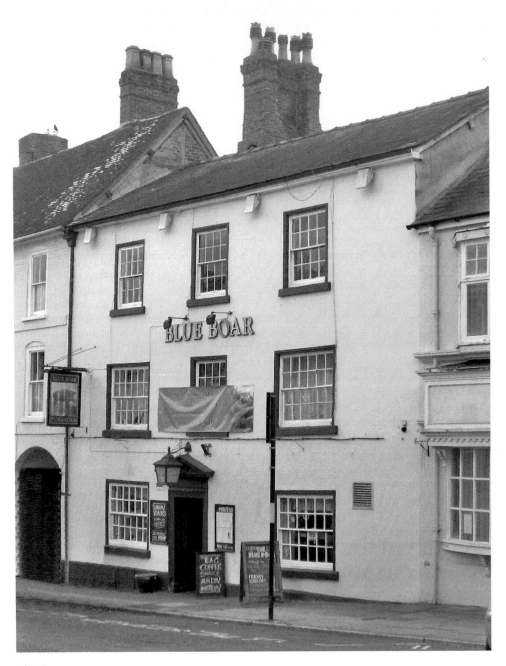

Blue Boar.

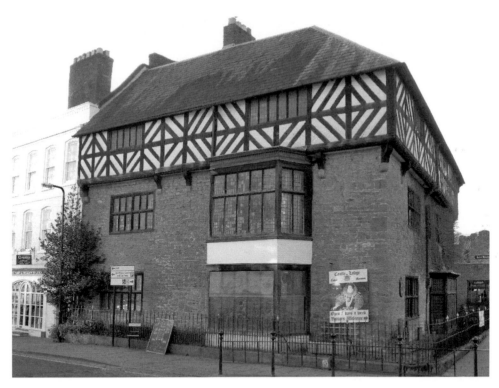

Castle Lodge.

It is perhaps best known as being a former home of Catherine of Aragon at the time she was widowed by the death of Prince Arthur. In later years Catherine was to marry Arthur's brother, Henry VIII, eventually to be forced into a divorce she did not want and banished from court when Henry married Anne Boleyn. The young Catherine of Aragon may have found some happiness in Ludlow, which may be why her ghost is said to still haunt the upper floors of the Castle Lodge.

The apparition of a young lady in Tudor clothes has been seen by visitors to Castle Lodge, usually disappearing through a wall. One of the most detailed recorded sightings of Catherine was made by the famous ballerina, the late Irène Skorik. Known as Gwen to husband Bill Pearson, the present owner, she initially thought that someone had got locked in after they had closed up for the day. Described as an absolutely solid looking figure, she was only a matter of feet away when she passed straight through a wall. She was able to give Bill a quite remarkable description of the apparition:

The figure was about 5 foot tall. She was wearing a golden collar but a man's cloak according to fashion books of the time. It was a cloak for going out in. Underneath she was well dressed. She had this golden, woollen, high quality dress. Her hair was gathered in a snood or net. She had something around her neck – a single stone that sparkled – probably a single diamond. The strange thing was she was wearing red gauntlets and hanging from the gauntlets there was a chord with a big red bobble on

the end of each one. She seemed very happy and not pale as in the pictures but quite ruddy faced. She seemed very happy, skipping and running along the corridor before disappearing through the wall.

Visitors to the Castle Lodge report all sorts of strange experiences especially on the upper floor around the oddly shaped room at the end of the landing leading from the stairs. Cold spots are common, as is the feeling of not quite being alone even if no-one else is up there. Some years ago, the author was involved in a paranormal investigation here which took place mainly during the day. The following is my recollection of what happened:

> Around lunchtime people went off to get something to eat but I opted to take advantage of the quiet building and stayed behind. I was sitting at the very top of the stairs on the upper floor looking towards the little room at the end of the landing. All of a sudden, I clearly heard loud footsteps crossing the wooden floor in the room though I couldn't see anyone through the open door. My immediate thought was that it must be a colleague who I hadn't realised was in there. I got up to go and talk to whoever it was and as I walked along the short landing the loud footsteps suddenly stopped. In my mind I assumed that whoever it was had walked across the room to look out of the window to the market square below. As I entered the room I immediately realised there was no-one in there and the only door was the one I had just walked through.

If you have the opportunity to visit Castle Lodge, be sure to try and spend some time on that upper floor. You never know what you may experience there!

CHANG THAI RESTAURANT AND GLOBE BAR (FORMERLY THE GLOBE)
Market Street
Ludlow
SY8 1BP

The Chang Thai Restaurant and Globe Bar was formerly The Globe Inn. The popular licensed restaurant is now housed in the part of the building which was the original Globe and the present Globe Bar is on the other side of the old carriageway dividing the two buildings. The front of the restaurant in the ancient Market Street still retains the name and pub sign of the old Globe Inn.

There is a well-known ghost haunting The Globe and the area around nearby Market Street. He is reputed to be Edward Dobson, a soldier who was killed in a pub brawl at the inn around 1553. His ghost is seen wandering around described as wearing a cloak and wig. Within The Globe itself his ghost is said to haunt the place where he fell down dead but floating just a little way off the present day floor level.

An apparition has also been seen upstairs when the old inn had guest rooms but it seems this may not be Edward Dobson, as this figure is a very old gentleman with wispy

The upper floor of Castle Lodge.

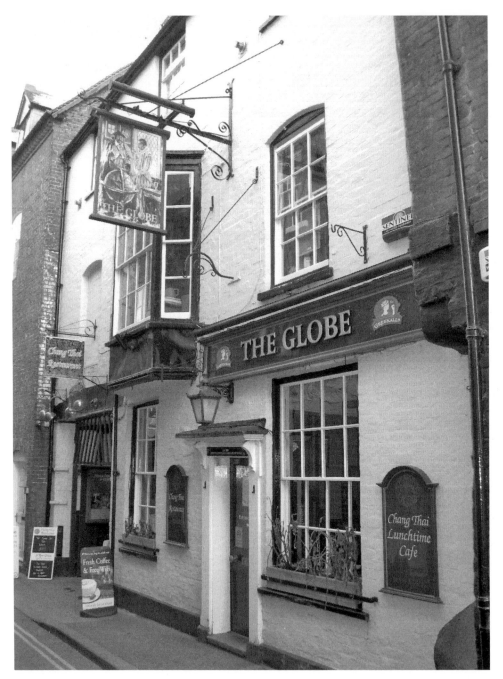

Chang Thai Restaurant and Globe Bar.

silvery hair. Dressed in night attire he walks the entire length of the building. When he has been seen, usually in the early hours of the morning, witnesses have assumed him to be just another guest. It is only when they have described him at breakfast that they discover no such person was staying there at the time. No living person that is.

THE BULL HOTEL
14 Bull Ring
Ludlow
SY8 1AD

The Bull Hotel is a Grade-II listed medieval hostelry offering freshly produced food and real ales in its comfortable lounge, bar and restaurant. Both the restaurant and the hotel accommodation have been recently refurbished and it is situated close to the centre of historic Ludlow. It is certainly one of the oldest buildings in Ludlow. It was recorded as being Peter of Proctors House in 1343 but the oldest part dates back to 1199 and probably started life as housing for the stonemasons and artisans who built nearby St Lawrence's Church. Internal alterations some years back revealed a previously unknown priest hole and internal well. It is thought to have become The Bull Hotel sometime in the fifteenth century.

Uncovering the sealed up priest hole led to all sorts of paranormal activity immediately afterwards, such as loud footsteps in rooms when there was nobody there and people getting tapped on the shoulder or feeling that someone had just brushed past them. Licensee, Debbie Richards, only moved to the hotel in November 2011, but was already well aware that things were going on here:

> We have put things down in one particular spot when there's no one else in the room and you turn around and they're at the side of the room or moved altogether to a completely different floor. I haven't actually seen anything but I can put something down and two days later it'll turn up in a completely different room, floor or part of the pub altogether.

One of the barmaids who used to work at The Bull Hotel has seen glasses moving along the glass shelves on their own, caught on CCTV camera. At other times glasses have been known to come off the shelf as if someone had pulled them out before smashing to the floor some distance away.

Debbie was aware of stories about a bishop or priest who is said to wander around particularly in the top apartment area. A few years ago the landlady at the time saw something move in the bar on the CCTV system. She paused the tape and saw what looked like the dark figure of a bishop or priest with his hands together just looking out of the front window towards the road.

The former barmaid confirmed that shadowy figures had been seen by a number of people and she herself had quite an unnerving experience in the top room at the end of the long bar:

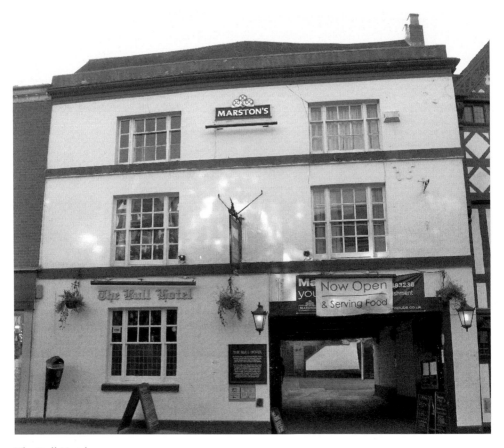

The Bull Hotel.

> I was completely alone in the pub. I saw someone walk from one end [of the top room]
> to the other and so I went up there. No-one was there but I swear I saw someone like
> a man actually walk across.

According to Debbie, Room 3 particularly is the one to stay in to experience Gertrude,
the little girl who wanders around the letting rooms. The story goes that hundreds
of years ago when cattle used to be slaughtered in the yard at the back the young
Gertrude got trampled to death by a rampaging bull. If you should happen to meet
with her spirit, she apparently likes to be called Gertie.

A flight of old steps in the yard at the back of The Bull Hotel leads to the churchyard
of St Lawrence's Church. On summer evenings in particular, the apparition of an old
lady in a long dress has been seen passing through the churchyard from the direction
of the old rectory. When she reaches the door of St Lawrence's Church she simply
vanishes away into thin air.

THE FEATHERS HOTEL
The Bull Ring
Ludlow
SY8 1AA

The Feathers Hotel in Ludlow regularly features on lists of outstanding hotels for both its architecture and its ghosts. The building is featured in Pevsner's *Architectural Guide to Shropshire*, and justifiably so for its superb Jacobean architecture. The timber façade dates back to 1619 when it was constructed by a local attorney, Rees Jones. Thomas Jones, the son of Rees, fought in the English Civil War as a Royalist Captain and it was he, in about 1670, who turned The Feathers into the hotel and hostelry it still is today.

The Feathers is said to be haunted by a number of ghosts including one relatively recent apparition seen not in the hotel itself but immediately outside. This particular ghost has been seen on a number of occasions but the story is similar in each case. On one such occasion a businessman, late for a meeting one day, parked his car immediately outside the hotel. In his rush to get to the meeting he left some important papers in the car. Turning to return to his car he was greeted by the sight of a young girl in a mini skirt half walking and half gliding across the road towards him. The businessman soon realised this was no living person, however, as she passed straight through his car and glided onto the pavement before promptly disappearing.

Other ghosts reside within the hotel itself. Staff and guests have witnessed the apparition of a Victorian gentleman walking with his dog between rooms 232 and 233. The man and dog appear to be real until they pass straight through the wall between the two rooms before disappearing. Room 211 appears to be home to a jealous female ghost who takes a distinct dislike to women. On one occasion a female guest's hair was pulled so violently she was almost dragged out of bed. Gentleman generally fare better, however, as they are likely to feel a gentle caress on their face if she likes them.

When Sylvia Silk escorted a group of Americans on a 'Great British Haunted Pubs' tour she wasn't expecting to have a haunting experience herself:

Our first overnight stop was at The Feathers Hotel in Ludlow. I was chatting with our tour guide Val on the coach *en route* to Ludlow about the hotel when she told me about her paranormal experience when her last group stayed there. Val told me that the room she stayed in made her feel very uneasy in spite of its beautiful décor and the four poster bed, and that she did not get any sleep the whole time she was there.

When I checked into my room before dinner I decided to make myself a cup of tea. The electric kettle had a very short cord and had been placed in a very awkward place to reach. I tried to remove the cord so that I could put some water in the kettle but it was stuck and I could not reach the electrical socket as it was located behind a heavy piece of furniture. Desperate for a hot drink as it was freezing outside I poured water into the kettle using a tea cup.

When I retired to my room later that night I started to feel a sense of foreboding. Memories of my conversation with Val about her last experience were firmly planted in my mind making me feel worse. Then I decided I was being silly and tried to brush

The Feathers Hotel.

off the feeling as I got ready for bed. While I was in the bathroom brushing my teeth I heard a loud noise like something had snapped. I went into the bedroom to investigate the source of the sound to find that the electrical cord of the kettle had been flung across the room and was lying on the floor next to my bed. I immediately turned on the television and kept both the bedroom and bathroom lights on all night as the sense of foreboding intensified. Needless to say I did not get a wink of sleep after that experience and was so relieved when we checked out of the hotel the following morning.

It seems both Sylvia and Val before her may have had first-hand experience of the unfriendly spirit who takes exception to the presence of female guests, and does her best to ensure that they don't get a good night's sleep. Guests should also be prepared for the very real possibility of other ghostly experiences whilst staying at The Feathers Hotel. Sounds like children running along the corridors and clapping or tapping are often heard by staff and guests alike. Nothing unusual in that for a family hotel you might think, except children are not normally running around playing in the very early hours of the morning.

THE WHEATSHEAF INN
Lower Broad Street
Ludlow
SY8 1PQ

Described as a little bit of country in the heart of the town, the Wheatsheaf Inn serves a range of real ales and in true inn style offers good food and comfortable accommodation. Situated next to Ludlow's historic Broad Gate, the pub was first licensed in 1738 but is much older than that. After being severely damaged in the English Civil War, it was rebuilt in the 1600s. As with many properties of this age there are stories of long blocked up tunnels, possibly used by local soldiers or priests evading arrest. The present building incorporates Chandler Cottage which forms the far end of the building where there is a lovely old fireplace.

According to landlady, Susan Murphy, it can feel cold at times in the area which used to be Chandler Cottage even though the pub itself is warm and comfortable. Room 4 is immediately above this area and this, too, can be subject to inexplicable chills. Sue sometimes feels she is not alone in the bar even after everyone has gone, 'At night time when I come to lock up you get this bit of a sense that there's something behind you'.

Visiting the inn now, it is hard to believe that at one time it was a rough and bawdy establishment. During the 1600s it was used by ladies of ill repute, a whore house in fact according to Sue. This might provide an explanation for the ghost who is traditionally associated with the building. No-one knows who he is but he certainly makes his presence felt, to ladies that is, by pinching their bottoms as he passes by.

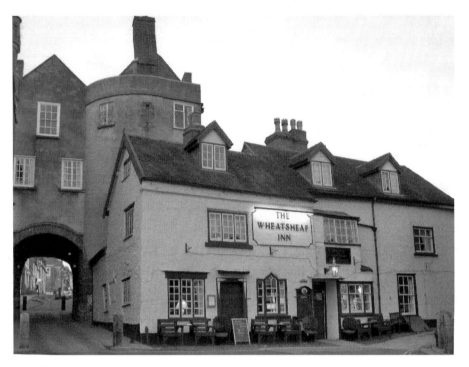

The Wheatsheaf Inn.

Chandler Cottage end.

YE OLDE BULL RING TAVERN
44 The Bull Ring
Ludlow
SY8 1AB

Ye Olde Bull Ring Tavern is a Grade-II listed, black and white timbered building in the heart of Ludlow. This family pub and restaurant dates back to 1365 and the interior still contains original oak panelling in the lounge. As far as is known it has always been a tavern making it one of the oldest hostelries in Ludlow.

At least two ghosts are known to haunt the tavern. One of the previous landlords was downstairs whilst a female member of staff was working in the upstairs kitchen. At the time there wasn't anyone else up there. Suddenly, she came flying down the stairs saying, 'Quick, I need a brandy!' She told the landlord she had just seen a woman come through the upstairs restaurant area wearing a long grey dress, sweeping through the room. The landlord said she described the phantom figure as looking like she could perhaps have been a Victorian nanny or something similar.

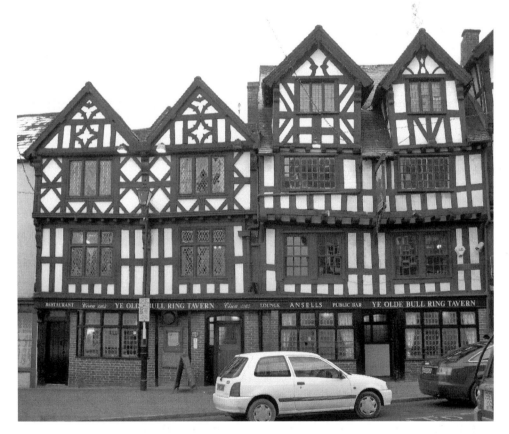

Ye Olde Bull Ring Tavern.

Hundreds of years ago there was a fire in the building. At the time a little lad was employed as coal boy and he worked in the coal room which was a little space separate to the cellar. He had been sleeping in the coal room when the fire took hold and unfortunately perished there as he was unable to escape the flames. Staff describe the cellar as being creepy and cold. Many are quite reluctant to go down there and perhaps with good reason. A previous landlady went down into the cellar one day and had the shock of her life when the little coal boy emerged from the coal room right in front of her. She wasn't down in the cellar for very long that day.

MARKET DRAYTON

CORBET ARMS HOTEL
High Street
Market Drayton
TF9 1PY

The Corbet Arms was looking forward to re-opening after a major refurbishment at the time of writing. A seventeenth-century coaching inn, it was called The Talbot prior to 1825. Thomas Telford used the Corbet Arms Hotel as a base whilst overseeing the building of the Shropshire Union Canal. However, it is not known whether he ever had any experience of the ghost who haunts this particular hotel.

The story concerns a chambermaid who became besotted with a handsome guest at the hotel. He seems to have taken advantage of the situation by promising to marry the attractive but naive young girl. Almost inevitably she fell pregnant with his child but with the promise of marriage was not unduly perturbed. Not, that is, until one morning when she discovered her lover had left the hotel leaving no forwarding address and no means of contacting him. Realising that her predicament would most likely lead to being kicked out onto the streets she chose to take her own life instead. She was discovered hanging by the neck from a hook in the rafters in Room 7 where her lover had stayed.

Since then, her ghost has continued to haunt the Corbet Arms Hotel and particularly Room 7. Single men staying in the room are likely to have their bedclothes pulled off during the night as she searches for her errant lover. She is often seen smiling from the end of the bed before gradually fading away. Young men she particularly favours have felt a light kiss on the cheek or even had their bottom pinched!

Her footsteps are also heard running through the hotel, particularly around Room 7 and the stairs at the rear of the building. Jewellery has also been known to disappear only to reappear sometime later in a completely different place.

It often seems to be the case that when buildings are refurbished or undergo major changes an increase in paranormal activity results. Certainly the ghostly chambermaid of the Corbet Arms will have been starved of male company during the hotel's closure.

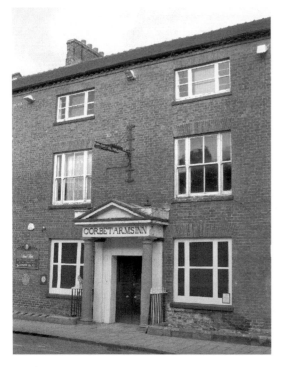

Corbet Arms Hotel.

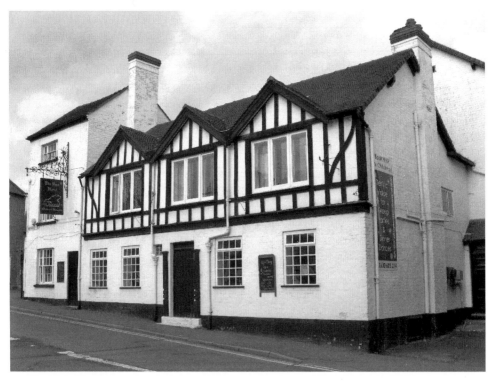

The Bear at Hodnet.

THE BEAR AT HODNET
Hodnet
Market Drayton
TF9 3NH

The Bear is a sixteenth-century black and white timber coaching inn situated in the pleasant village of Hodnet. As well as offering a traditional bar, log fires, excellent food and accommodation, the Bear is also renowned for hosting its medieval banquets. The name most likely derives from the presence of a bear pit believed to have been sited where the car park is now. In common with other inns of its time, The Bear lays claim to secret tunnels which may have been connected with the local church or used to avoid the payment of tax on transporting alcohol.

The friendly ghost who haunts The Bear even has a lounge bar named after him, 'Jasper's Lounge'. The story of Jasper, like many such tales, varies slightly depending on who is telling it, but the essential elements are always the same. Jasper was a gentleman who liked to visit the inn as he travelled around on business. He was well liked and would often buy rounds of drinks and enjoy sumptuous meals and jovial hospitality.

Due to some less than favourable business dealings Jasper found himself down on his luck and in mid-winter, with only a light coat to shield him from the cold, he sought shelter at The Bear where he had previously been made so welcome. Realising that Jasper did not have the means to pay for his food and lodgings he was cruelly thrown out by the landlord into the bitter cold winter's night.

Some hours later the landlord, having gone to fetch some provisions from a store, staggered back into the bar speechless. With a contorted, terrified look on his face he died there and then right in front of his shocked customers. The medical opinion was that he had died of a severe heart attack brought on by extreme fright. When the store was checked everything was found to be as it should be with no clue as to what it was that had literally scared the landlord to death. The following day the body of Jasper was also found huddled beneath a hedge, frozen to death. Was it Jasper's ghost that had so terrified the landlord and caused his untimely death? Since then Jasper's ghost has been seen many times in the inn and particularly around the top of the stairs. Certainly staff and customers who have seen the ghost of Jasper say he is far from terrifying. Well dressed and jovial he still wanders the inn he loved so much in life.

MOREVILLE

THE ACTON ARMS
Haughton Lane
Moreville
WV16 4RJ

The Acton Arms is a friendly village inn offering quality food and beverages. It has past connections with the Aldenham Estate and a stained-glass window in the inn portrays the coat of arms of Richard Maximilian Lyon-Dalberg-Acton, 2nd Baron Acton of Aldenham. The area is steeped in history and during the English Civil War escaping Royalists were said to have hidden two chests of gold belonging to Charles II in the brook which runs nearby. The chests can still be seen in the nearby church, but sadly not the gold.

At one time there was a priory in Moreville connected with Shrewsbury Abbey. The Acton Arms has had a long association with ales as the brew house for the priory was originally here. In those days, it is said a tunnel connected the two buildings. Unfortunately, no trace of the tunnel remains but one of the monks who may have used it is still very much in evidence.

So much so that Marc Alexander in his well-known book, *Haunted Inns*, was moved to call The Acton Arms, 'England's most frequently haunted pub'. A wispy white form in the shape of a man wearing a monk's habit is seen darting from room to room, usually upstairs. He is thought to be a Benedictine monk associated with the old priory. A previous landlady from the 1970s used to see him frequently, sometimes appearing to be kneeling in prayer. Quite why he is still here no-one knows but licensee Tom Bradbury confirmed that people had told him they had regularly seen and heard strange things in the building.

According to Tom, one of the stories told to him concerns an old gentleman who sits quietly in the corner opposite the stained-glass window. Watch out for him if you visit The Acton Arms but look away for an instant and he may suddenly be gone.

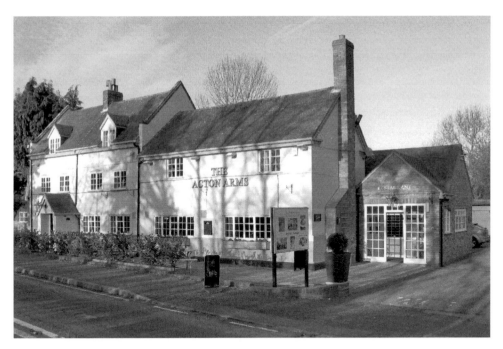

The Acton Arms.

MUCH WENLOCK

THE GEORGE AND DRAGON
2 High Street
Much Wenlock
TF13 6AA

The George and Dragon is a character seventeenth-century inn situated in the very centre of the historic market town of Much Wenlock. Real ales and traditional home cooked pub food coupled with a friendly welcome for locals and visitors alike makes The George and Dragon well worth a visit. Former staff member, Pete Arden, provided a curious bit of historical information about the pub which will hopefully be checked out one day. The staircase is so narrow that there is supposed to be a 'coffin drop' behind the fireplace. This was a chute designed to allow coffins to be dropped down easily from the upstairs rooms.

The George and Dragon is reputed to be one of the most haunted properties in Shropshire. A fact landlord James Scott and landlady Bev Mason weren't aware of until after they had moved in. As they both explained the most well-known ghost in the pub is not a person at all but a black dog. The story dates back to the early 1800s and concerns a particularly unpleasant landlord. He was a drunkard who used to mistreat his dog and lock it in the cellar without food or water. One particular serving wench would wait until the landlord fell into a drunken slumber and then she would release the dog from the cellar to give him food and water. The ghostly dog still haunts the pub and has a particular liking for women. His presence manifests mainly as a chilling feeling around the legs. He is sometimes seen out of the corner of the eye but as soon as you turn to look directly at him he is gone.

Bev used to hear the dog regularly when she was a child and her mother worked at the pub. 'I used to hear the black dog walking down the quarry tiles. I'd look and there was no-one, nothing there.' Bar staff working here have also heard and felt things, particularly the coldness moving around their legs. Bev actually saw a dog behind the bar late one night. She had come down to make a drink in the kitchen and was stood looking along the corridor towards the bar and thought her own dog had come down

from upstairs and gone behind the bar. She ran down to get him only to find the bar deserted. Her own dog hadn't moved from upstairs.

The serving wench who used to take care of the black dog is also said to haunt The George and Dragon. She is seen in the oldest part of the pub where the back restaurant is. She walks past from the utility room to the cellar where the dog was kept. A previous member of staff used to see her walking past the windows. The kitchen door swings when she passes through as James explains:

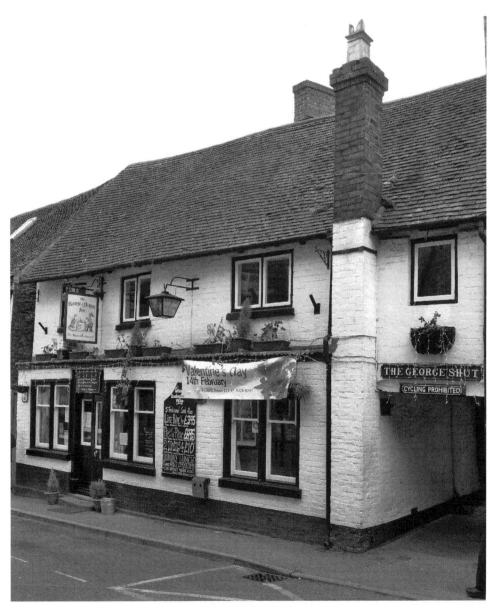

The George and Dragon.

The door swings by itself. I had one experience where the door was moving and we were having a staff meeting. I literally held open the door and called out, 'Come on, come through' and I let go of the door and it stopped swinging! I can tell you I didn't want to think about that one too much!

Yet another presence is experienced upstairs in the pub. Very often when it is quiet footsteps are heard walking around the upper floor. A friend who visited the pub was sceptical of this until he heard the footsteps for himself. Convinced there must be someone up there he was told to go and look for himself. He went up and ran straight back down again saying, 'There's no-one up there – I'm not going back up!'

The office upstairs can feel very eerie and as James says, 'When I'm doing the paperwork sometimes it's like there's someone stood behind me.' Bev and others have had the same feeling in there too:

We never mentioned it to each other. Our niece looked after the pub and was in there the once and our bar supervisor had been staying the one night cashing up and mentioned that it was a bit eerie. I said, 'How do you mean?' and they both said, 'when you're sat there you feel like somebody's staring through and peeping round the corner'.

A friend and her boyfriend did some holiday cover for James and Bev and stayed upstairs:

They looked after the pub for us when we went away in November [2011]. The boyfriend went to the toilet and there's a mirror opposite and he saw somebody in the mirror. He screamed and ran into the bedroom! He said, 'I've just seen somebody in the mirror.' She said, 'Yourself?' He said, 'No!' That scared him just slightly!

In the bar, James has known glasses to come flying off the shelves for no apparent reason:

It's literally from one side of the bar to the other side. They always tend to break as well whereas if you drop a glass behind the bar it will usually bounce. They always seem to shatter. There's dropping and then there's flying – slight difference!

Pete Arden, who used to work at the pub, also had the experience of seeing a pint glass lifted off its hook and thrown behind the bar.

Yet another figure is seen from the bar area at the front of the pub. If you visit The George and Dragon keep an eye on the little opening where the bar is. Often there is someone standing there, but look away and back again and they are gone.

THE WENLOCK EDGE INN

Hilltop
Much Wenlock
TF13 6DJ

This charming old fashioned country inn was formerly called The Plough. The building most likely began life as quarryman's cottages before being turned into the country inn it is today. The whole area around the Wenlock Edge Inn and the inn itself is steeped in local legends and ghost stories.

One of the older stories associated with this area is that of the medieval robber knight, Ippiken. He and his band of cutthroat villains had a hideout in a cave under an outcrop now known as Ippiken's Rock. From here they would terrorise and rob unwary travellers, returning to the safety of the cave with their ill-gotten gains. Until one day that is, when during a violent storm a massive piece of overhanging rock fell and trapped the gang inside the cave where they all perished. There are stories of strange lights being seen around the area at night and, if you have the nerve, you can challenge the ghost of Ippiken himself. From the top of the cliff shout 'Ippiken, Ippiken! Keep away with your long chin'. However, be warned. Legend has it that the ghost of Ippiken, angry at being so rudely addressed, will rise up and fling whoever disturbs him off the cliff to their certain death.

Not far from The Wenlock Edge Inn is the Major's Leap which is named after a Royalist officer, one Major Smallman. During the English Civil War he was being

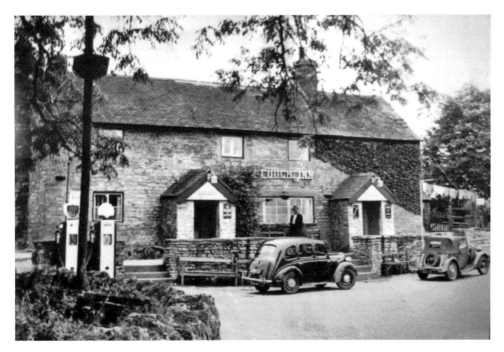

The Plough.

pursued by Parliamentarian soldiers after fleeing from Wilderhope Manor. In order to evade his pursuers the Major chose to jump his horse off Wenlock Edge rather than be taken alive by the Roundheads. Miraculously, Major Smallman survived the leap without serious injury and made his escape although his unfortunate horse was killed. His ghost reputedly re-enacts the event to this day, man and horse seen in full flight disappearing over Major's Leap.

The isolated and lonely road running past the inn has a particularly alarming ghost, especially if you happen to be the one driving. The tall figure of a man has been seen on a number of occasions to step right out in front of passing cars giving the drivers no chance to brake or avoid hitting him. However, when the shocked occupants get out of the car there is never any indication that an accident has taken place and no trace of the mysterious man.

With so much ghostly activity in the area it comes as no surprise that The Wenlock Edge Inn itself is haunted. This ghost seems to be a friendly sort of chap who goes by the name of Jack. He was most likely a quarryman and probably lived in the building before it became an inn. Jack makes his presence felt by moving objects around and occasionally saying 'hello' to people. His distinctive pipe tobacco can also be smelt at times and as smoking is no longer allowed in pubs nowadays this is even more noticeable when it occurs. Everyone agrees that Jack is a friendly spirit who is still around looking after the place. If you visit the inn keep a careful lookout for Jack as sometimes he can be seen in the pub and in the bedrooms upstairs, but usually people just catch a fleeting glimpse of him out of the corner of their eye.

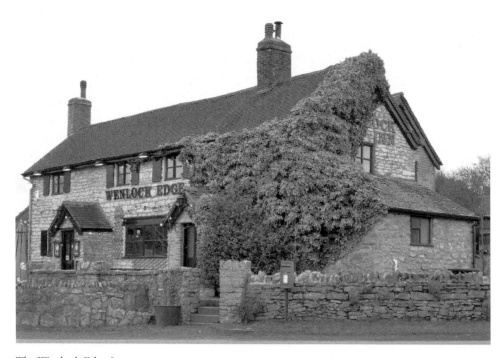

The Wenlock Edge Inn.

NEWPORT

LILLESHALL NATIONAL SPORTS AND CONFERENCING CENTRE
Near Newport
TF10 9AT

Lilleshall Hall dates back to 1831 when it was originally constructed as a hunting lodge for the Duke of Sutherland. Nowadays, the magnificent building forms the centrepiece of Lilleshall National Sports and Conferencing Centre. As well as state-of-the-art sporting facilities the hall itself is a hotel housing Chapters restaurant and bar.

Gareth Goodwin was employed as overnight manager at Lilleshall Hall from 2000 onwards and he has the following to say about the hall:

> I was fortunate to be employed as an overnight manager. Most of my time was spent manning the front desk in reception as throughout the night guests came and went. One particularly quiet night just after I started working there I was listening to my portable radio which was on the counter to my left. The radio was the type that has to be turned on by a rather tight sliding switch. All of a sudden it just went off. I picked it up to look at the batteries thinking they may have come loose but no, the slide switch was firmly in the off position.
>
> During other times at reception I've heard noises like coins being dropped on the counter and keys being moved around. Sometimes when the weather was rather stormy the atmosphere around reception would suddenly change. It would become so uncomfortable that I would have to get away from the area. On returning after a while the atmosphere would be back to normal again. It was if it was being suggested that I should go.
>
> Once as I was coming out of the room behind reception I saw what I took to be the back of a person wearing a long gown going into the reception area. I duly followed and I wished I hadn't, for when in that area I experienced the most unpleasant of feelings, hair standing up on the back of my neck and my fingers tingling. There was no sign of the lady I had followed in there.

Alone on reception during the night there were often strong smells of pipe tobacco, ladies perfume and the sound of doors opening even though no-one was about. I would see shapes passing by just out of line of sight and once the brief sighting of a woman standing to my left. She appeared to be wearing a top garment over a long dress. I have seen this woman elsewhere around the Hall. In the large dining room which has a capacity of five hundred people, a figure was quite often seen and even identified as a long dead night matron, Evelyn. She was often seen by the area that is now used as a wash up.

The first floor of the hall is now used for offices although years ago they were bedrooms. Odd things are heard up there at night such as voices speaking quietly and doors closing when there is no-one else up there. On the top floor the rooms are now bedrooms. This is where the old nursery used to be. It is a strange room with windows half way up the walls and an odd platform under one of the windows. In this room, (which is now room 202), things have been seen such as mists, and the furniture gets moved around.

There is a story about this particular room. Back in the days of the Duke, who was partial to a drink or two, he would leave his younger wife to travel into town. She got very bored and took herself a male companion. When the Duke had left for

A drawing of the original Lilleshall Hall by Sophie Homer.

his evening's entertainment, she would let her friend into the hall by a back door. To prevent the Duke coming back unexpectedly and discovering them, she would station a maid on the platform in room 202 to watch out for the Duke's return and warn the Duchess that it was time to get her friend to leave. This went on for a year or so, and then one night the maid fell asleep and the Duchess and her friend were caught. The maid was punished and the Duchess Garden that the Duke had built for his wife was destroyed. Perhaps this explains the haunting in this area. In the extensive gardens there is an area still known as the Duchess Garden, not far from the hall. This is where I saw the figure of a woman, possibly the same figure I saw in reception, as she briefly appeared in front of me walking away at about 100 yards distant.

The last Christmas I was on duty over the holiday period some of the areas in the hall were not entered into and kept locked. During these times there were no guests or staff on site, just myself and my other work colleague who worked the day shifts. One particular morning at about 6 a.m. I was on reception after a very quiet night. Suddenly, a noise started from the floor above the reception area. This area had not been entered into since before the Christmas holiday. This was a very loud noise. At first I thought it might be the heating system, as that could be noisy sometimes, but this was much louder like heavy furniture being dragged around. Nothing could be seen from downstairs so I went up to have a look. As soon as I got near to the area the noise stopped. However, after my colleague started work it did start again for over half an hour. Again, no explanation for this could ever be found.

The hauntings are not just restricted to the Hall and gardens either. In the other sport's halls things have been seen and heard. For example in Ford Hall horses have been heard in the early morning and also a figure of a man has been seen.

Gareth was ideally placed to experience the hauntings here, working mainly alone overnight when the building should be quiet. He even obtained permission to set up a video camera in the hope of recording some of this activity. However, as is often the case, the camera was never in the right place at the right time to record anything. As Gareth himself commented, 'The pattern of haunting there was very patchy and most of the time totally unexpected when it happened.'

THE KINGS HEAD
Chetwynd End
Newport
TF10 7JJ

The Kings Head was an old coaching inn and is these days a real ale pub. Records show it was a coaching inn at least as far back as 1747. The rear of the building is much older though, and still contains an example of medieval cruck timber frame construction. It is mainly in the older part of the pub where strange experiences occur.

Customer Trevor Smith has stayed at The Kings Head and at one time was employed to paint the interior of the pub. One night Trevor took a break from the painting and

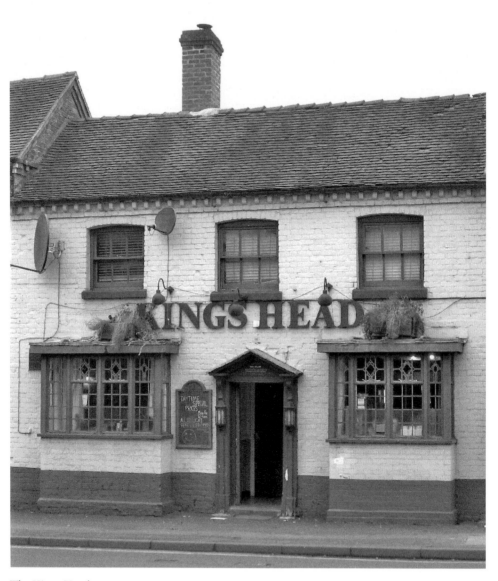

The Kings Head.

came into the bar to make a hot drink. 'I made myself a cup of tea and I just turned to go and do some more painting and I saw a little boy's face just in the doorway to the loos.' It was just his face that Trevor saw with no visible body although the face was about the right height for a child. Trevor was talking to landlord Mick Collins some time later and it turned out that he, too, had seen a little boy's face in the same doorway. The child's face that Trevor had seen reminded him very much of the iconic picture of a very young Jackie Coogan, peering around a corner with Charlie Chaplin taken from the 1921 film, *The Kid*.

In the older part of the building both Trevor and Mick have had the experience of seeing visual anomalies passing through the rooms. Trevor described them as being bright white orbs, some moving slowly and some moving quite quickly before they suddenly disappear. As described they sound very similar to the kinds of orb effects commonly captured on digital cameras. The big difference here is that these are actually seen, rather than caught on camera, and seen with the room lights on.

Trevor has also heard odd noises, 'I've heard a knocking on the back wall in my room, quite a few knocks on the wall.' Intrigued to know what might be on the opposite side of the wall where the loud knocking was coming from Trevor went outside to take a look. 'It was one day in the summer. I went up the garden to look and I noticed that that wall is actually an outside wall and nobody could have been up that high to knock on the wall.'

Other people staying in the older part of the building have had the experience of waking up in the early hours of the morning to find their bedclothes being pulled off them by unseen hands. On a number of occasions bedclothes in one particular room would be found stuffed behind the headboard. As Mick explains, 'The bed covers would end up behind the headboard and would have had to have been physically forced down, not just thrown down – that was a regular thing.'

OSWESTRY

THE GREEN INN
Llangedwyn
Oswestry
SY10 9JW

The Green Inn is a picturesque rural country inn dating back to 1740. Locally sourced, home cooked food and a range of real ales are on offer in this very traditional village pub. The building was originally two farmer's cottages and as far as is known has served travellers and locals alike as an inn for the past two hundred years. The upstairs restaurant area used to be a grain store with the living accommodation on the ground floor. The building next door is at least a hundred years older and was once the local morgue.

Despite being such a warm and comfortable old pub, owners Emma Richards and Scott Currie are aware of a lot of sadness in the building dating back over many years. In the front bar the spirit of a man who committed suicide there is felt. Apparently he came in one day, ordered and downed a drink and promptly shot himself in front of the assembled company. The sadness of another suicide victim is felt in the little extension to the lounge which was only added in the 1960s. Previous to this time it was a patch of land behind the inn and it was here that that some tormented soul decided to end their misery by hanging themselves.

It is upstairs around the restaurant area though that most of the activity here is experienced. Emma has seen a figure walking across the top of the stairs. At the time, there was a frosted glass door there and Emma clearly saw the figure walk across from left to right. Initially thinking it was Scott, she quickly realised he would have had to have walked through a solid wall. However, as Scott explained, when the pub was a fully functioning inn the figure would actually have passed through a long gone door to one of the bedrooms. On one occasion Emma had an even clearer sighting of the figure. She was standing in the upstairs kitchen with the doors open and saw a man dressed in tweed and a flat cap walk across. 'I thought it was Scott, then I thought no, he's wearing a flat cap and breeches it can't possibly be him!'

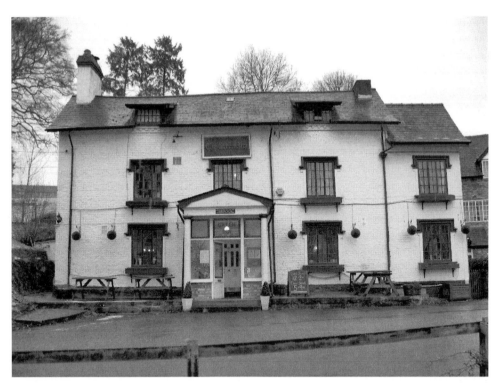

The Green Inn.

In the upstairs restaurant a ghost known as the Lady in Green roams through the rooms. She is a very elegant Victorian lady in a long green velvet dress with a hoop and wearing a lace trimmed bonnet. She is seen coming through the cocktail bar and into the restaurant before disappearing towards the window. She is another sad figure as she is said to be searching for her little baby who died in one of the bedrooms.

A very noisy spirit inhabits one of the upstairs rooms which may at one time have been used as an office. Emma and Scott have both heard him banging around in the room when there is no-one upstairs. According to Scott, on occasions when they hear someone banging around upstairs the alarm will go off as well even though there is never anyone there. When he was on his own one day Scott also had the unsettling experience of hearing someone coming noisily up the stairs though again, there was no-one to be seen.

Immediately outside the pub the old road leads to the top of a hill where an old hanging tree used to stand. Prisoners sentenced to death in the local court would be hanged there and their bodies brought down by horse and cart past the inn on the way to the graveyard. On occasions the macabre spectacle of the coffin wagon is said to still go thundering past carrying some unfortunate soul to their last resting place.

Although The Green Inn has a Shropshire address it is not too far from the Lake Vyrnwy Dam. The dam and associated waterworks was constructed in the 1880s to provide drinking water for Liverpool and Merseyside. At the height of its construction

a thousand men were employed but not all were to survive. A memorial obelisk at Lake Vyrnwy lists the names of the forty-four men who were killed building the massive structure. The dam took seven years to construct and consequently many men moved their families to the area whilst working on the project. One such family lodged at The Green Inn in the 1880s when the upstairs rooms provided accommodation. The family had a little girl who always used to sit and wait for her father to come down the road at the end of the working day. Following a terrible accident at the dam he was killed and became one of the forty-four men whose names are inscribed on the memorial. The ghost of the little girl is sometimes seen sitting in the upstairs restaurant window still patiently waiting for her daddy to come home.

THE SMITHFIELD HOTEL & RESTAURANT (FORMERLY THE BEAR)
1 Salop Road
Oswestry
SY11 2NR

The Smithfield Hotel & Restaurant incorporating the Bullring Bar and Lounge was created out of two former licensed properties, the Old Black Gate and The Bear. Situated in the centre of Oswestry, The Smithfield incorporates bars, a restaurant and comfortable accommodation whilst still retaining the character of the original buildings.

Much of the activity at The Smithfield centres on what is now Room 8. Indeed, paranormal activity has been going on here for many years. The daughter of a previous landlady recently visited The Smithfield and related how terrified she used to be as a teenager when Room 8 was her bedroom. At times she felt that someone or something was trying to stop her getting out of the room. Even though the door would be unlocked she would be unable to open it against the pressure of some unseen force. She was very adamant that she would never venture up into Room 8 again. She also had an experience one Christmas time whilst taking photographs in what was The Bear. Looking behind her she saw a man and a woman dressed in what appeared to be Victorian style clothing just standing in the pub.

Landlady Charlotte Thom confirmed that, 'Room 8 always feels cold even though the heating can be on and the rest of the hotel is lovely and warm.' More recently, a resident staying in Room 8 awoke to see the bathroom door opening by itself and a figure standing in the bathroom though he said he couldn't make out any specific details before the apparition disappeared.

Charlotte has had her own experiences here, particularly in the now joined Bull Ring which used to be the Old Black Gate:

Things often get moved here. I will put something down, go to pick it up again and it will have disappeared only to reappear somewhere else. Sometimes there are unpleasant feelings in this part of the now joined building. One night I was in bed and heard two big bangs from the bar below in the Bull Ring when no-one else was

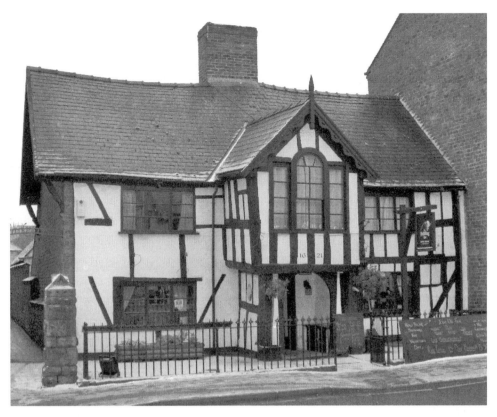

The Smithfield Hotel & Restaurant.

there. I called my husband and when we checked a previously locked door had been opened and a price list in a glass frame had been inexplicably thrown across the bar and smashed on the floor.

There were no signs of anyone having broken in and Charlotte is convinced she had locked up securely before retiring to bed as she always does.

THE THREE PIGEONS NESSCLIFFE
Holyhead Road
Nesscliffe
Nr Shrewsbury
SY4 1DB

The Three Pigeons Nesscliffe is a country pub restaurant dating back to 1405, serving locally sourced produce and real ales. The pub is closely connected with the infamous highwayman, Sir Humphrey Kynaston. Sir Humphrey was found guilty of murder and outlawed by Henry VII in 1491. As a result of this he took to living the life of a

highwayman between 1491 and 1518, basing himself in a nearby cave on Nesscliffe Hill which can be seen to this day. The cave was divided into two rooms and seems to have been a relatively comfortable shelter for both the highwayman and his magnificent horse, Beelzebub.

He has been described as Shropshire's answer to Robin Hood as he was known for robbing the rich and giving to the poor. In return for this he not only received food for himself and his horse but also protection from arrest. The Three Pigeons was Sir Humphrey's local hostelry and he even had his own seat in the inglenook fireplace there. The present day fireplace is said to incorporate Sir Humphrey's original sandstone seat, taken from the cave. A long lost tunnel was believed to exist under a trapdoor by the fireplace. In order to evade arrest Sir Humphrey would use the tunnel to escape to the base of Nesscliffe Hill and safety. There are many stories of Sir Humphrey Kynaston and one of them has him receiving a pardon from Henry VIII in 1518 for having supplied a hundred of his men to help fight the French.

According to the landlord, he and his family have had many strange experiences in the pub but not all linked with Sir Humphrey Kynaston it seems. Not so long ago a lady visiting from Canada and her family all met up at the pub. Her niece took a photograph of her sitting in a chair with a digital camera. Everyone present was amazed to see three additional people on the picture. There was an old gentleman, a woman in her fifties and a young child, none of whom were visible when the picture was taken. Restaurant Manager, Natasha Brooks, also saw the photo. She described the faces as being strangely 'misty' but very detailed:

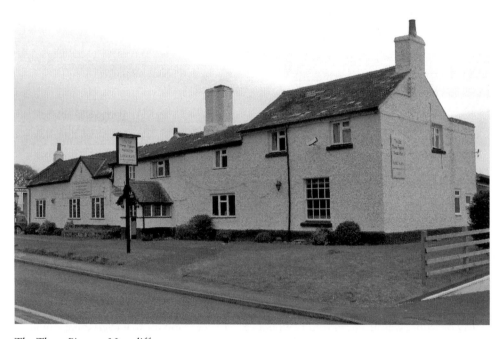

The Three Pigeons Nesscliffe.

I could see the woman was smiling and I could see the line of each tooth. The man's face was long and he seemed very proud and there was a little girl with curly hair. They were almost as though they had run into the picture and gone 'cheese' just like in old photos. The picture was amazing; it was just surreal with the three faces.

The bottom restaurant is in part of the original old building and it was here that one diner was treated to a spectacle he definitely wasn't expecting. Behind the pub and visible through the back window is a thick hedge which is a relatively new addition given the age of the property. He saw a galloping horse pass right through the hedge just as if it wasn't there. When he was able to explain what he had seen, he described the horse as being white and saddled up but without a rider. Natasha remembers the incident, 'That so scared the man he didn't want to finish his meal. He wanted to go he'd had such a fright!' He knew nothing of the Sir Humphrey Kynaston stories and so wouldn't have known that his mount, Beelzebub, was reputed to be a magnificent white horse.

In the bottom restaurant again, a table of four people were sat having a meal and chatting when two of the company suddenly had a most disconcerting experience. They both had the feeling that someone had just walked straight through them. They didn't see anything; they just had the intense feeling of a presence passing through them as they sat at the table.

According to the landlord, the most frequent thing that happens here is that people standing at the bar get tapped on the shoulder but when they turn around to look there is no-one there. The locals have got so used to it that they don't take any notice of it now. There is frequent activity upstairs in the building, particularly in the old part. Loud banging is heard though the source can never be traced and a workman refurbishing a room up there refused to go back on his own after just one day! Working alone he kept getting tapped on the shoulder and was convinced someone was in the room looking at him. Curiously, when the activity is at its height, if someone asks it to stop or just calm down it does so. This was the case with the workman. After staff had persuaded him to go back they asked whoever or whatever it was to leave him alone and he had no more incidents after that.

When the present landlord was about fourteen he saw a ghost who could have been Sir Humphrey walking across the floor in the bar. He was dressed in a black cape and was staring at the youngster as he passed through to the other side of the pub where he just disappeared. He looked exactly as a real person would apart from his very old fashioned attire and the fact that he was walking about a foot and a half above the existing floor. On questioning this, the lad was told that people were very much smaller in 1405 when the building was constructed. Consequently, in later years, when people were taller, the floor had been lowered by approximately eighteen inches, or a foot and a half.

Restaurant Manager, Natasha Brooks, used to live in at the pub at one time and whilst doing so she experienced quite a lot of poltergeist-type activity:

My bedroom was an *en suite* and I would get into bed knowing that everything would be off and suddenly the taps would come on, and you'd hear the running taps. So, I

would have to get out of bed and turn the taps off. Sometimes the lights would go on and off and once when I got into bed the music came back on downstairs.

Small things like bunches of keys are prone to disappearing and appearing again in obvious places. Natasha has had this happen to her on numerous occasions, 'For instance I'll lose something and suddenly it will be right bang in the middle of the table where I knew full well it wasn't.' She and others have witnessed the heavy kettle in the fireplace suddenly start swinging around even though the wind never makes it move. Despite these occurrences Natasha has always felt safe in the pub. 'They all joke that he likes me. People say they've been pushed or had a fright but I've never been given a fright and never felt scared.'

About six years ago Natasha had an experience that would frighten most people. At the time she had met her fiancé and was spending much less time at the pub. Natasha describes what happened:

> I had a key and I'd locked the flat upstairs and the one time I came back and everything in my bedroom (except the really heavy things) like the bedside table, some clothes I had left lying around and the telly were all on the bed. It was just all piled up on it which was really freaky for me!

At the time there was no explanation for what had happened. The room had been locked and even if they had a key there was absolutely no reason for anyone to go in and do that to a room that Natasha wasn't using as often anyway. Could it have been that the protective presence of Sir Humphrey Kynaston was missing Natasha and, jealous of her new fiancé, had messed up her old room to demonstrate his extreme displeasure?

SHIFNAL

NAUGHTY NELL'S
1 Park Street
Shifnal
TF11 9BA

Naughty Nell's was closed for refurbishment at the time of writing after a cellar fire in May 2010. This 500-year-old, Grade II listed coaching inn was originally called The Unicorn. It was a popular stop-off point for London coaches in the eighteenth century and the whole area must have been bustling with people and trade.

Local legend has it that it was the home of Nell Gwynne, mistress to Charles II. Certainly there are royal connections with the area as Charles was in hiding at Boscobel House and Moseley Old Hall after the Battle of Worcester in 1651. Nell Gwynne herself may have been born in Hereford but it seems the Nell associated with Shifnal may, in fact, be the fictional Nell Trent from Charles Dickens's *Old Curiosity Shop*. His grandmother is said to have worked at nearby Tong Castle and Dickens himself visited the town on a number of occasions. Tong Church claims to have the grave of the fictional Little Nell, but this seems to have been created for the benefit of tourists in the early 1900s. This grave is also sometimes wrongly attributed to Nell Gwynne as she was buried in the church of St Martin-in-the-Fields, London. The confusion would probably have amused Nell Gwynne as she was referred to by Samuel Pepys as, 'Pretty, witty Nell'. The two Nells seem to have become inextricably entwined in local folklore.

The Naughty Nell's does lay claim to at least four ghosts but it seems most unlikely Nell Gwynne herself puts in a spectral appearance here. Disembodied voices have been heard within the building and loud banging sounds heard emanating from locked and empty rooms as if someone were trying to get out. This could possibly be connected with the great fire of 1591 which destroyed much of the old Shifnal.

Even though the Naughty Nell's is presently closed it is still worth a visit as a figure has been seen standing in one of the upstairs bedroom windows looking out over the main street when the building has been known to be locked and empty.

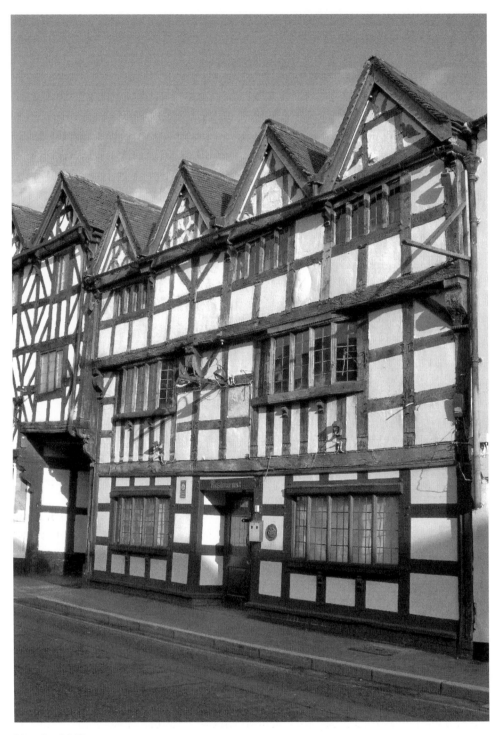

Naughty Nell's.

THE ANVIL INN

22 Aston Road
Shifnal
TF11 8DU

The Anvil is a traditional old inn with additional hotel accommodation. On the day I visited a roaring fire was burning in the comfortable front bar area of the pub. According to records the building goes back to at least 1701 but in all likelihood is even older than that. It is certainly one of the older inns in Shifnal which was a busy coaching route during the eighteenth century. The original blacksmith's anvil which gave the inn its name still exists in the wood yard opposite, where wainwrights would once fabricate and repair the wheels of the London stagecoaches stopping over in Shifnal.

Landlord Mike Davies and his staff have had a number of unusual occurrences in the old inn since Mike took it over some fifteen years ago. The following is typical of the experiences Mike has had:

A few months ago I kept catching things out of the corner of my eye and I was thinking it might be my new glasses. Anyway, I was sitting here on my own watching the television one night after everyone had gone and I kept having this feeling there was something over by the bar. This kept happening as I was watching the late night news and all of a sudden in the mirror over the fireplace I saw something or somebody walk straight behind the bar. Now who or what it was that I saw I really don't know. What I did then was I turned the lights out and went off to bed. Normally I do the cellar but I didn't do it that night!

At the time of this experience Mike was completely on his own downstairs in the pub and there was certainly no sign that anyone had gained entry to the building.

According to Mike the cellar also has a distinct feeling that there is someone watching you from behind all the time. Whoever it is may well be watching over The Anvil Inn itself. At one time they started having problems with the gas bottles in the cellar supplying the cold drinks up in the bar. The gas bottle in the corner of the cellar would keep getting turned off even though no-one had been down there to do it. This carried on for a while and Mike couldn't work out what was happening. Eventually, he got a friend who was a gas engineer to take a look. As soon as he got down into the cellar the engineer said there was a serious problem but not with the gas bottles. He had immediately detected a leak where the main gas pipe comes into the pub. A joint which should have been gas tight was loose and natural gas was slowly leaking into the cellar. Without the cold drinks gas bottle being regularly turned off the natural gas leak might well have gone unnoticed, eventually spelling disaster for the pub with all the electrical equipment down there. According to Mike, 'That was quite strange really because we never had any problems with the gas bottles after that.'

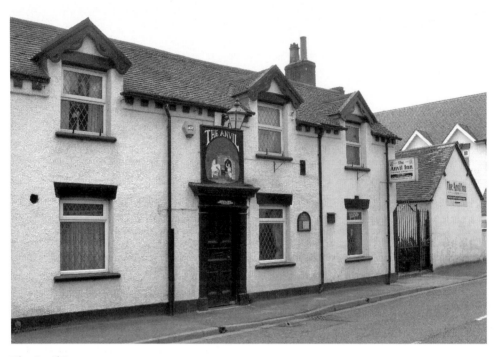

The Anvil Inn.

The Anvil Inn fireplace.

THE BELL INN

Newport Road
Tong
Shifnal
TF11 8PS

The Bell is a handsome early nineteenth-century building nowadays situated on the A41 at Tong. It was built as a country inn by local estate owner George Durant in 1811 to serve the local population and travellers on the earlier London to Chester turnpike road. The pub has a warm and family friendly atmosphere and offers an extensive two for one food menu. A large conservatory has been added to the original period building and it is here that the ghost haunting The Bell makes her presence felt.

According to Catherine Leese, who worked at The Bell as a General Supervisor, 'I've seen sightings of a young girl running from one side of the conservatory to the other and she's been witnessed as well by other employees of The Bell.' The little girl is described as having long curly hair falling half way down her back and she is always wearing a pretty dress. The little girl also likes to play with the cutlery:

> If you're cleaning a table you'll just sometimes catch a glimpse of her or you know she's been around because she moves the cutlery. She puts the knives and forks cross

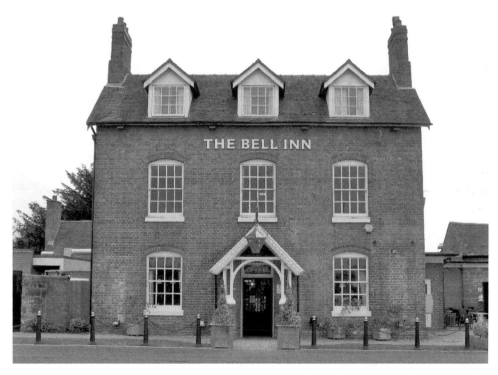

The Bell Inn.

ways to each other. That would be around half eleven at night when no-one else is in and after you've finished setting out the cutlery in the conservatory.

Catherine also had a rather scary experience when she was staying in the pub on her own one time. After retiring upstairs to bed she could hear chattering coming from downstairs as if the pub was still busy. Needless to say, there was no-one else there at the time and the source of the voices was never discovered.

THE WHITE HART
High Street
Shifnal
TF11 8BH

The White Hart is a black and white, timber framed building first licensed in 1620 as a coaching inn. In those days, however, there was scarce room for the many London coaches passing through Shifnal so it was mainly the horsemen who would stay. These days The White Hart is a warm, welcoming traditional pub serving good food and real ales. Owner and landlord Andy told me one of his customers once said that walking into The White Hart was like putting on a comfortable old pair of slippers.

Despite a healthy scepticism about such things, Andy has had a number of experiences during his time at The White Hart:

We have an office on the landing upstairs and at the time my daughter would have been about three. Something attracted my attention which made me look over my shoulder and I saw what I thought was her. A little girl with long blonde hair was going into our bedroom. I thought she was playing a joke on me so I thought I'd play one on her instead and creep up on her. However, having entered the bedroom and had a good search for my daughter I actually found nothing and no-one. There wasn't a feeling of coldness or fear or anything like that I just thought I was seeing things.

The bedroom only had the one door so whoever or whatever Andy saw go into the bedroom that day could not possibly have gone out any other way.

A visit from a Civil War re-enactment society seemed to stir something up in the pub as Andy relates:

The Sealed Knot were staying at Weston Park to do a show and they all came down here for the real ale. It was about a week later and I was closing the pub up on a Saturday night. I was here in the lounge and I'd just locked the front door. As I came back and looked across over into the main bar there was a guy there in full regalia. He had a big wide brimmed pointed hat, a silvery blue paisley tunic and a red kerchief of some sort. Across his chest was a black or brown belt and he had a big beard and a very pointed nose. He was holding what looked like a pewter jug as if he wanted to be

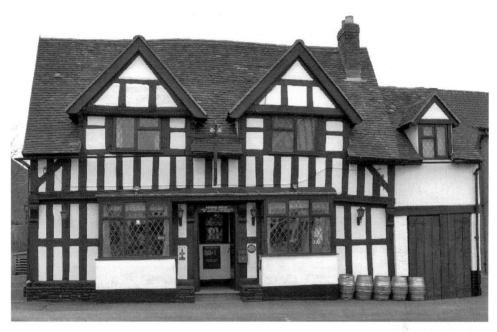

The White Hart.

served. I turned away and looked again and he was gone – had he still been there I'd have been a bit worried I think and it made me retreat rather quickly!

Andy had a Rottweiler at the time of this incident and shortly afterwards he was on his own in the pub having a coffee in the lounge with the dog asleep by his side. All of a sudden he shot up with his hair standing up on end growling as if there was an intruder. Andy let him into the bar and he was just barking at something unseen in there – right where Andy had previously seen the Civil War apparition.

The rear of the lounge is also subject to loud inexplicable noises coming from the landing above when there is no-one up there. The noises have been heard on a number of occasions and Andy describes it as sounding like a brush falling over with the stave striking the wooden floor with some force. Not so unusual in such an old building except that the landing above is fully carpeted.

SHREWSBURY

THE DUN COW
Abbey Foregate
Shrewsbury
SY2 6AL

The Dun Cow dates back to the eleventh century which makes it one of the oldest working pubs in the country. It was originally built for skilled workers employed to build nearby Shrewsbury Abbey and probably became a public house early in the twelfth century. A Tudor refurbishment to the building saw Spanish oak from dismantled galleons installed, which are still present and visible to this day.

The pub is steeped in history and during the English Civil War Prince Rupert, nephew to Charles I and commander of the Royalist cavalry, used The Dun Cow as his personal lodgings. It was during this time that a Dutch cavalry officer made the fatal mistake of murdering Sir Richard, a member of Prince Rupert's personal staff. Retribution was swift and final as, following a hasty court martial, the Dutch army officer was hung by the neck until dead for his crime. It is said that before execution he bemoaned the fact that he was meeting his death for the killing of only one Englishman. His troubled ghost still haunts The Dun Cow and has been seen in full cavalry uniform in various parts of the pub. He has apparently even been mistaken for a member of a Civil War re-enactment group until, that is, he disappears through the wall. Loud footsteps heard pacing around the upper floors may also be down to the Dutch officer replaying his last hours before meeting his premature death.

A hooded monk also haunts The Dun Cow and was seen in the 1980s by the then landlord's wife, a Mrs Hayes. Waking up one night she witnessed the hooded figure stooped over her baby's cot. Unusually, Mrs Hayes described the monk's habit as seeming to be covered in little coloured dots. The figure promptly disappeared but returned to terrify the unfortunate child when she was around two and a half years old and able to ask why there was a scary man in her bedroom. The monk is often seen by staff and customers alike as a shadowy figure moving around within the pub and disappearing through the walls.

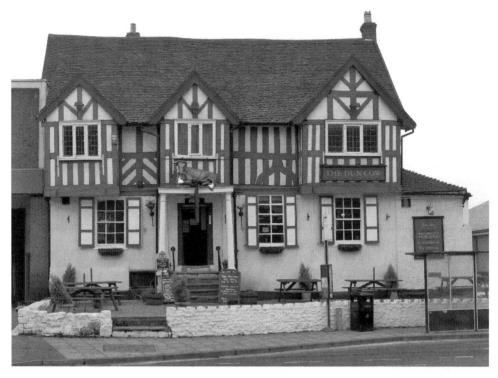

The Dun Cow.

THE GOLDEN CROSS HOTEL
14 Princess Street
Shrewsbury
SY1 1LP

The Golden Cross is a family-run hotel and restaurant dating back to 1428. This lovely old building was originally constructed as the Sacristy for St Chad's Church where the vestments would have been kept under the watchful eye of the Church Sacristan who would have lodged here. Originally a protective-covered walkway would have connected the building and the ancient shut or passageway to the nearby church but this is now long gone. The Golden Cross is one of the earliest recorded hostelries in Shrewsbury and has a reputation for hospitality and as a meeting place going back over the centuries.

Owner Gareth Reece was happy to tell me about the ghosts haunting The Golden Cross. He and his guests over the years have had many experiences including the elusive ghost who likes to keep the passageway clean. As Gareth explains:

> I've been down here in the restaurant at about two o'clock in the morning and I've heard it. I've gone to the back door of the cellar and it's not the sound of a broom, it's the sound of a besom you hear. You know the old twig broom. I've heard it go from

the top of the alleyway to the bottom back door and I've been stood just the other side of the door. It's been that loud and I've flown out of the door and jumped into the alleyway only to find nothing there! I've had people staying up in the bedrooms and they've said, 'The council are a bit keen around here aren't they?' They've been moaning about them sweeping the alleyway in the early morning.

At one time the Vicar's Choral, a group of professional religious singers, were lodged in Golden Cross Passage. Traditionally the area is supposed to be haunted by the ghost of a monk so perhaps it is he who continues his work of keeping the alleyway clean for the regular processions of the Vicar's Choral to and from St Chads.

Inside The Golden Cross things are equally as active. Particularly around May time an extraordinarily strong smell of liniment is experienced on the back staircase going up onto the top landing. According to Gareth, 'You'll be standing there and it's like someone lathered in heat rub is stood right next to you.'

During the Second World War a young Air Force officer shot himself in Room 4. It never feels warm in there and is often chillingly cold. Children are heard running up and down the corridors as well, even though there are no children present at the time. Around Christmas time Gareth has heard the distressing sounds of frightened children trying to escape from a long ago fire in the building.

In a room known as the Old Red Room, which was an old meeting room, the sound of someone walking around is heard. The floorboards are very creaky in this room and the sound is unmistakeable. When Gareth goes to look, 'You double check, go through the building but there's no one there. You get used to it though, it's really weird. I haven't heard the sweeper for a few years but my guests can hear him, they still hear it.'

THE HOLE IN THE WALL
1 Shoplatch
Shrewsbury
SY1 1HF

The Hole in the Wall is a Grade-II listed building created from two older pubs, The Hole in the Wall and the Mardol Vaults. There are records of an earlier inn on the site called The Gullet and an even earlier medieval manor house which is central to the story.

The on-going haunting here concerns the tragic story of Lady Sarah, whose ghost still walks through the pub. She was apparently a member of the Shutt family who are believed to have owned the much earlier medieval manor house. She was deeply in love with a boy from St Chad's Church and used to sneak out to meet him there. Her father found out about the liaison and strongly disapproved, banning her from ever seeing him again. Sarah was banished to her room and broken hearted she starved herself to death.

According to Manager, Chris Lawton, people have seen Lady Sarah walking through the pub from where the toilets are now at the front of the building and down into The

The Golden Cross Hotel.

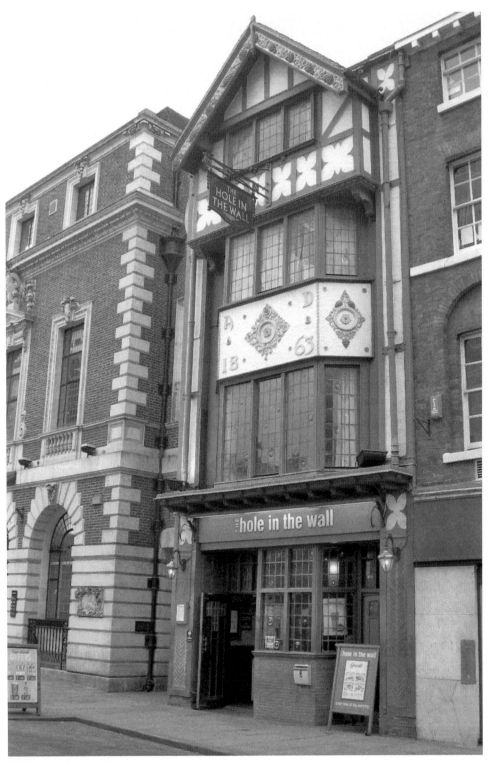

The Hole in the Wall.

Hole, which was the old Hole in the Wall before the pub was rebuilt. Chris explained why she is seen walking from the toilet area, 'People have seen her going this way because where the toilets are that's where the stables used to be and apparently she used to walk up and down here.' Witnesses to the apparition of Lady Sarah have said that she seems to be smiling as she sweeps through the present day pub before disappearing in the area now known as The Hole.

THE LION HOTEL
Wyle Cop
Shrewsbury
SY1 1UY

The Lion Hotel is a magnificent Grade-I listed, sixteenth-century coaching inn and hotel situated right in the centre of historic Shrewsbury. Despite being steeped in history, this very traditional hotel offers visitors a warm and friendly welcome even if only stopping off for a drink in the comfortable Oak Bar. The hotel preserves many period features including a Tudor fireplace, an oak panelled bar and the stunning Adam Ballroom built in 1770. The hotel has played host to many famous guests over the years including Charles Dickens and Madame Tussaud. The hotel has even had a book written about it, *Four Centuries at The Lion Hotel* by John Butterworth, cataloguing the complete history of this most fascinating of buildings.

With such a rich history it is hardly surprising that The Lion Hotel has its fair share of ghostly activity. Owner, Howard Astbury, was pleased to show me around and share some of the stories. The bar area is said to haunted by the ghost of a soldier possibly from the English Civil War period and the basement, where there was once a chapel, is home to at least one female ghost. When staff have been preparing for a function in the Adam Ballroom they have been aware of somebody passing through the room. According to Howard, 'you think somebody's walked through the room and then you realise you haven't heard any footsteps! There's nobody there'. An apparition known as The Grey Lady likes to put in an appearance on the stage itself. Quite a few members of staff have experienced this.

At the rear of the Adam Ballroom is a wide room with a large fireplace. Howard described an experience the Housekeeper had here:

> ...and then we had our Housekeeper who was cleaning out the fireplace. She was cleaning the top of the fireplace and there were two big candles on top. She took them off and she put them on the table and one of the candles just flew off the table and went straight across the other side of the room which scared her a little!

Some of the activity here seems to be centred on the staircases rather than the rooms themselves. A night porter doing his rounds was coming down the staircase not far from the Ballroom. As he approached the closed door in front of him at the bottom of the stairs unseen hands opened it for him to pass through. Residents at the hotel often

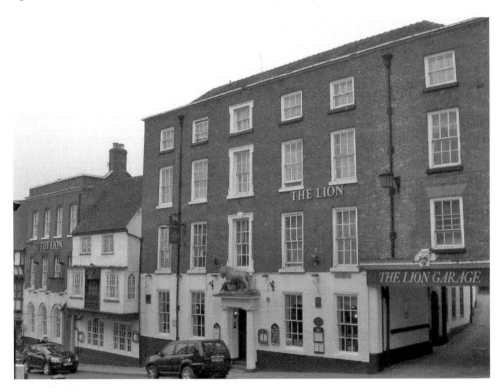

The Lion Hotel.

The haunted stairway.

The bottom of the stairway.

think they are following someone down the stairs only to find that there was no-one there when they reach the bottom.

On the staircase leading up to the Adam Ballroom a lady is sometimes seen. She appears to be waiting for someone, possibly a gentleman friend, but she seems to have been waiting for quite some time as witnesses describe her dress as Victorian.

THE NAG'S HEAD
22, Wyle Cop
Shrewsbury
SY1 1XB

The Nag's Head in Wyle Cop dates back to the fourteenth century. The jetted upper storey and rear of the structure are both original features and the building was one of those used for the filming of *A Christmas Carol* by Charles Dickens in 1984. It is appropriate that the pub be used for the filming of a classic ghost story as it has one of its own.

A mysterious painting of a figure on the inside of a cupboard door upstairs has become associated with stories of ghosts and a chilling warning. Local legend has it that anyone who opens the cupboard and looks at the picture will be driven insane to

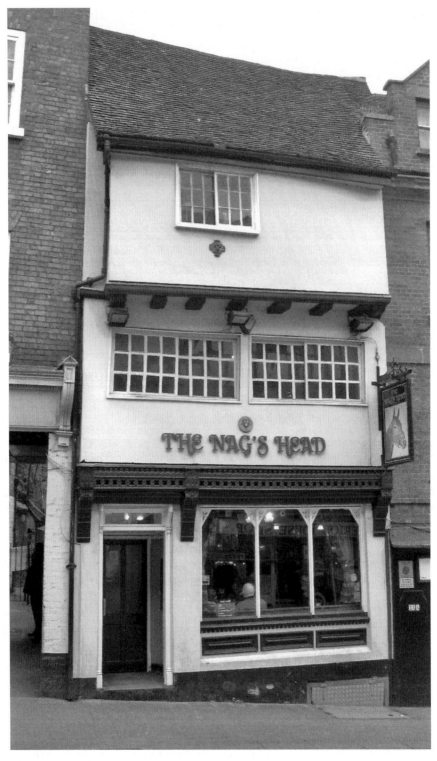

The Nag's Head.

the point of committing suicide. This seems to have been the sad fate of at least three unfortunate souls who unwisely chose to spend a night at The Nag's Head.

A coachman from the days of horse-drawn travel hung himself in the pub and his ghost has never left. In fact, he may well be responsible for at least some of the activity here. A young lady with everything to live for inexplicably flung herself out of the bedroom window to her death. One story has it that if the strange picture is ever removed from the cupboard her ghost will also return to haunt the pub. The third suicide is much more recent and only dates back to the Second World War. A serviceman on his way home stayed at the pub and shot himself with his own revolver.

Given the tragic history surrounding the room containing the picture, unsurprisingly it is no longer used as a bedroom and is usually just kept locked. Even so, as landlord Russell Preece told me odd things do happen here. 'The jukebox has been known to come on at night and a hand dryer in the toilets.' The pub is subject to sudden extreme temperature drops and at times moaning can be heard along with the sound of someone sobbing and loud footsteps walking around when there is no-one upstairs.

THE PRINCE RUPERT HOTEL
Butcher Row
Shrewsbury
SY1 1UQ

The Prince Rupert Hotel is an outstanding building located in one of the oldest areas of Shrewsbury. The hotel incorporates a twelfth-century manor house with its original Jacobean staircase and stone vaulted cellar. Other parts of the hotel are from the fifteenth century and many of the period features throughout have been meticulously maintained and restored to their former glory. The hotel gets its name for being a former home of Prince Rupert, nephew to Charles I and commander of the Royalist cavalry during the English Civil War. The Prince Rupert is famously haunted and regularly features in top ten lists of the most haunted hotels in the UK. This is no mean achievement in a town like Shrewsbury where stories of hauntings abound around its medieval cobbled alleyways and black and white timber-framed buildings.

Much of the activity at The Prince Rupert Hotel occurs in two adjacent rooms, 6 and 7. Apparently the activity in Room 6 got to be that severe and disturbing for guests that the room had to be turned into a conference room instead. The story behind the haunting here concerns that of a newly-wedded young couple who had booked the room for their wedding night. Instead of beginning a happily married life together the bride was cruelly jilted and left alone in the room. Absolutely distraught she took her own life by hanging herself from the ceiling. Since then, the room has been plagued by poltergeist activity with things being moved around and hidden but this is not why the room was changed from being a bedroom. It was the sight of the jilted bride still hanging from the ceiling that used to so upset unsuspecting guests staying there.

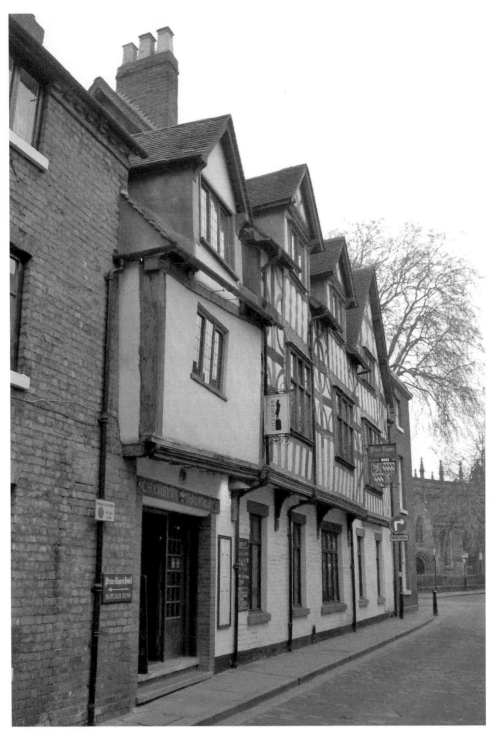

The Prince Rupert Hotel.

The adjacent Room 7, which is still a bedroom, was the site of another suicide. This time it was a bridegroom who killed himself but not connected with the bride in Room 6. Just before the wedding his fiancé and best friend ran off together leaving him heartbroken. His unhappy ghost is still seen roaming around this room from time to time. Less frightening poltergeist-type activity in the form of things being moved around is experienced in other rooms, too.

Another ghost here haunts the stairs around the Prince Rupert Suite in the twelfth-century manor house part of the hotel. She is Martha who once worked here as a maid and must have enjoyed her work as even after death she has never left.

Scenes for the movie of Charles Dickens's *A Christmas Carol* were shot in Shrewsbury and some of the film crew stayed at The Prince Rupert. Retiring to bed one night one of the directors encountered an old gentleman dressed in a nightshirt walking towards him along the corridor. Moving to one side to let him pass the director thought nothing of it until the old gentleman suddenly turned and passed straight through the wall.

TELFORD

THE STATION INN
Station Road
Horsehay
Telford
TF4 2NJ

For many years The Station Inn served passengers and staff of the Telford Steam Railway. At the time of writing The Station Inn was waiting to be reopened but Telford Steam Railway is a heritage line now open to the public on Sundays and Bank Holiday Mondays.

It is not so much the Inn itself as the station it served that is the subject of this particular haunting. The stories centre around the old engine shed on the Spring Village side of the station. At various times, but especially in the early hours of the morning, a figure has been seen or just heard walking along the platform inside the engine shed. Witnesses who claim to have seen the figure say that by his clothes he appears to be either an engine driver or fireman. Others have seen only a misty shape but more frequently it is the sound of loud footsteps that are clearly heard moving along the platform.

Paranormal investigator Gareth Goodwin and the author were involved in an investigation into the sightings at the engine shed a few years back:

By about 3.00 a.m. nothing of interest had occurred and we were considering packing up and leaving. However, we decided to spend one last session sitting quietly at the Spring Village platform end of the shed. Although there was very little light we could at least make out the dark shapes of the engines and equipment stored in the shed. After we had sat there for about half an hour we both heard what sounded like heavy footsteps coming from the other end of the platform. We knew there was no-one down there and looked at each other without saying a word to confirm what we were both hearing. The footsteps continued for a few seconds more and then stopped. We waited a little while to see if they would begin again and then made our way down the

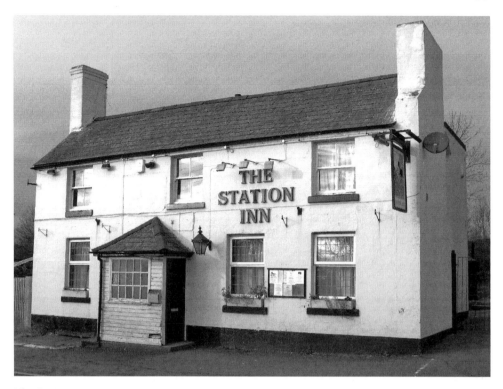

The Station Inn.

Horsehay engine shed.

platform to take a look. By this time we were fully expecting to find someone else in the building but a thorough search proved this not to be the case.

At the time we had an audio recorder running in a different part of the building which we didn't expect to have picked anything up from the platform. Although it is quite difficult to hear we were surprised to find that some of the footsteps had indeed been recorded.

WELLINGTON AND KETLEY

THE COCK HOTEL
148 Holyhead Road
Wellington
TF1 2DL

The Cock Hotel is a Grade-II-listed eighteenth-century coaching inn which stands on a much older site. It was opened to take advantage of the horse-drawn coach traffic along the busy Watling Street. First recorded as an inn in 1820, unlike many buildings of this age the interior has been kept as it was rather than refurbished. Original panelling is very much in evidence especially in the dining room. The Cock Hotel incorporates a bar known as The Old Wrekin Tap. This is a reminder of the long gone Wrekin Brewery which once supplied the ales here. Nowadays, a range of locally brewed real ales are on offer in this most distinctive hostelry.

There have been a number of ghostly occurrences involving both staff and customers at The Cock Hotel as licensees Pete and Liz Arden explained. Figures are seen in the downstairs bar areas and on the stairs. A very down to earth builder used to drink here and rather quietly asked one night if there were any ghosts in the building. He had been sitting having a drink when a figure passed through the door next to him and disappeared up the stairs. He was absolutely staggered and had never experienced anything similar before.

On another occasion around lunch time a lady came down from the upstairs ladies' toilet as white as a sheet. While she had been in one of the cubicles someone had come in and opened the door to the cubicle next to hers. The toilet flushed and the bolt was pulled across but no-one came out. Realising she was actually alone in there she fled back down the stairs in something of a panic.

A previous manager who worked for Pete and Liz used to be left in charge when they had a day off. They came back one day to find everyone talking about what had happened. The manager had gone into the Breakfast Room on his own to have his evening meal and closed the door behind him. He was sitting by the fireplace when a figure walked straight through the closed door and was walking towards him. When

the figure got to the point of walking through the table in the middle of the room, the manager took fright and shot out of the room locking the door behind him. The people in the bar who saw him said his hair was standing on end. Pete and Liz are not at all fazed by the activity and pointed out the absurdity of locking the door as the figure had just passed straight through anyway!

Another apparition has been seen in the bar by a friend of the licensees:

Now the chap who we bought the business from is also a personal friend and we sit talking sometimes. One day he actually got us to go and check in the bar because he said there was somebody sitting on the stool at the end of the bar. We said, 'there can't be we've secured everywhere and checked everything through' and we are fastidious about that but he wouldn't have it and we had to go through [to the bar] but there was nobody there.

Down in the cellar Pete often has the experience of smelling really strong tobacco. A few years ago this could have been put down to smoke in the pub finding its way down into the cellar. But now smoking is banned in licensed premises this explanation is no longer viable. Pete describes it as 'a really strong sort of pipe tobacco smell and you walk back to where you've just been and it's gone'.

When Liz was employed at The Cock Hotel some years ago she experienced something in the storeroom that would have unnerved most people:

I was here on my own. I'd done a lock up and I was just shutting doors up in the storeroom. I went to shut the door and it wouldn't come, someone was pulling on the other side of it! You can imagine when I was here on my own. I'm the sort of person who thinks there must be somebody behind there or something behind there I need to find out what. So, I stopped pulling and looked around the back and there was nobody there and when I came back it shut quite normally. It was very strong. I couldn't move it – so obviously one of them has got a sense of humour!

Upstairs is where the accommodation is and the top floor, which is in the roof, has seen its fair share of activity. A male guest who stayed up there one night, who wasn't a heavy drinker, awoke from a sound night's undisturbed sleep to find that the heavy wooden wardrobe had been moved across the room and was now blocking his door. This was the same floor where Liz's granddaughter was frightened by something when she was just three or four. She was absolutely adamant she had seen something but would only describe it as some sort of shape. Even though a teenager now, she still doesn't like going up to that floor.

On the first floor Liz herself has had a strange experience:

I was walking along the first floor and as I approached the far end of the building to turn to go down the back stairs there was this almighty flash of white that just filled the end of the corridor. I couldn't put a shape to it. I wouldn't say it went to the ceiling but … when something happens as quickly as that and you're not expecting it

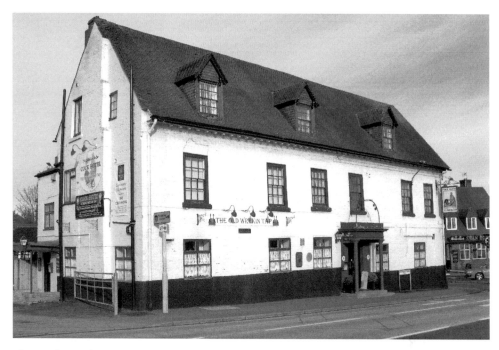

The Cock Hotel.

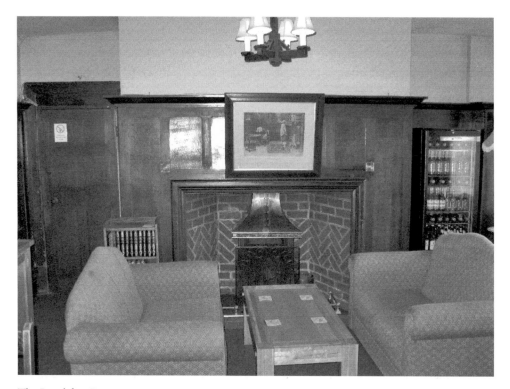

The Breakfast Room.

you don't really take it on board and it was so bright I thought, 'Wow what's that?' I looked away and looked again and it had gone. It was just as instant as that.

Room 3 on the first floor is reputed to be particularly active with the sound of doors opening and closing at all hours of the day and night as if travel weary stagecoach passengers were still checking in and out of The Cock Hotel.

SWAN HOTEL
106 Watling Street
Wellington
Telford
TF1 2NH

The Swan is a family run hotel which lies on the old Roman road of Watling Street. The present building stands on the site of a much older inn serving the busy coaching route to and from London in the days before the coming of the railways.

The ghost who haunts the present day Swan Hotel seems to date back to this earlier age of stagecoaches when Wellington was a regular stopover point. Given the name Humphrey by a previous landlord, he seems to be an amiable sort of presence. At the time of the great stagecoach routes the road was a dangerous place for anyone who looked like they might be carrying money. So it was for poor old Humphrey who was robbed and murdered in one of the rooms at the old inn.

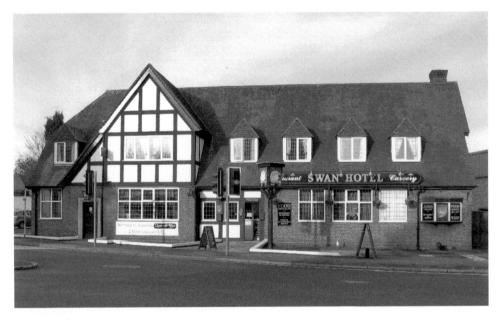

Swan Hotel.

These days, Humphrey makes his presence felt by moving things around. A guest might put something down on the dressing table only to find it moved somewhere else the next time they look. Animals particularly seem to be aware of Humphrey and are apt to act strangely when he is about.

As far as is known, he has only been seen once by a cook working at The Swan. He was walking along the upstairs landing wearing a long, heavy coat. Even if you don't see Humphrey, listen out for his footsteps. He is heard walking along the landing but as soon as anyone ventures out of their room to look the footsteps instantly cease.

LORD HILL INN
Main Road
Ketley Bank
Telford
TF2 0DH

The Lord Hill Inn has been a hostelry since at least 1844 according to available records, although the building itself is probably older. It most likely became licensed as a result of Wellington's Beerhouse Act and named after Lord Hill who was himself connected with Wellington. Rowland Hill, 1st Viscount Hill, served with distinction throughout the Napoleonic wars and was one of Wellington's senior commanders at the Battle of Waterloo. He is commemorated by Lord Hill's column in Shrewsbury, the tallest Doric column in England.

Liz and Pete Arden, who used to run the Lord Hill Inn, told me that the beer cellar was once the village morgue and still contains three recesses where the bodies would have been placed. Pete particularly has had some strange experiences connected with the cellar:

> One night I'd locked up and I was setting the alarm. A light came up on the panel to say there was a door open and would you believe it was the spirit store door! I thought that's funny because I knew I'd closed it. You have a routine don't you. So, I went downstairs and sure enough the spirit store door was open so I closed it, went back up and set the alarm again. It said spirit store door open – I didn't go back down again! It wasn't very nice so I just isolated the door out of the panel and that was the end of that. I wasn't going back down there again!

On other occasions even stranger things used to happen in the cellar when nobody had been down there:

> It was quite a big cellar area and the light was in the middle. More than once I've come downstairs in the morning and the light bulb had come out of the light fitting, bearing in mind it's a bayonet fitting. It would be lying on top of a barrel this light bulb, not broken, as if it had been taken out and placed there, and when I'd put it back in it would work.

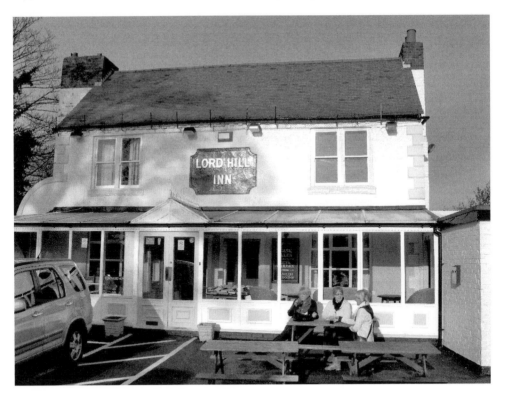

Lord Hill Inn.

The pub was originally two properties knocked into one which can be seen when you enter through the conservatory. There are two front doors which lead into separate bars. One night, after the pub had closed, Pete and the staff were in the right hand bar having a drink after closing up the left hand bar for the night. Liz drove up and immediately wanted to know who was in the left hand bar. 'I saw this shape, there were net curtains up and I just saw this shape walk across. I said somebody's in there and I've just seen them, as plain as day.' An immediate check of the bar revealed that there was no-one in there and all of the staff had been together in the other bar when Liz saw her phantom figure. Liz had a Jack Russell terrier at the time and he would never walk through the bar. He always had to be picked up and carried through.

According to Pete, whoever haunts the Lord Hill does not like change and particularly any new staff:

> We left there and the people that took over were customers so it's not as if they were strangers to the pub. The guy went down into the cellar one day and did what he had to do. He came back up again and couldn't open the door. The cellar door was absolutely shut solid. He just could not open it. He turned the handle and nothing would happen, as if it was locked and he couldn't get out. And then suddenly it opened and he got out. It had one of those long keys and it would go through the

door from one side almost to the other side and that key was bent over at 90 degrees as if someone had just bashed it.

Liz takes up the story:

He challenged his wife and a friend who was there. He challenged them and said 'what the hell were you mucking about at?' They both said they hadn't been near the cellar. Whoever and however many there were who knows? But they obviously didn't like him and he never went down the cellar again. They got quite a kick out of frightening people.

Liz thinks that the hauntings here are connected with the old morgue in the cellar. As she says, 'You don't know what troubled souls there might have been in that morgue and how many. That wasn't pleasant.'

THE WHITE LION INN
Holyhead Road
Ketley
Telford
TF1 5DJ

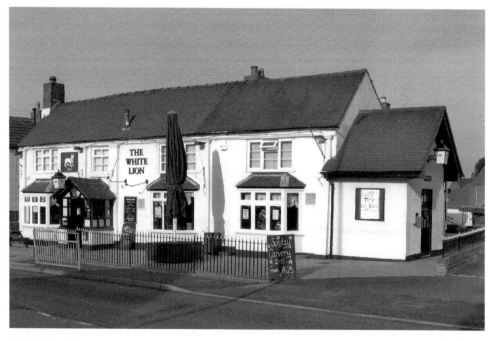

The White Lion Inn.

The White Lion Inn is a traditional family run hostelry offering locally sourced, home cooked food. A sign on the front of the building dates it back to 1661 when it was a coaching inn on the busy Watling Street. A local legend has it that Dick Turpin once stayed here. This is not quite as unlikely as it might sound because Turpin was known to have worked his criminal trade along the coach road which was Watling Street.

Proprietor, Debbie Dodd, told me that when they took over the pub in 2005 they quickly got to hear about the resident ghost:

> We have a resident ghost although we've never seen him. His name is Charlie and he does things like turning the gas off in the cellar and setting the ladies' hand dryer off in the middle of the night. He's turned the water system off in the gents which no one else would do because you have to have a ladder to turn it off. He comes through the doors and we hear the doors bang but nobody comes in. One room upstairs is where our Assistant Manager lives. Very often he [Charlie] switches the telly on in the early hours of the morning very loudly so everybody hears it. Often when we know our children aren't upstairs we hear running across the landing and we go up but there's nobody there.

Debbie considers Charlie to be a friendly, playful ghost who likes nothing more than playing tricks on staff and customers alike.

WEM

WEM TOWN HALL
High Street
Wem
SY4 5DG

Sitting in the pleasant café bar of the vibrant new Wem Town Hall Arts and Community Centre it is difficult to imagine the scene of utter destruction which took place on 19 November 1995 when the original town hall burned to the ground. Amongst the crowds gathered that night was amateur photographer, Tony O'Rahilly. One of the photographs taken on black-and-white film with his 200mm lens appeared to show a young girl standing in the doorway to the fire escape of the fiercely burning building. The Wem 'girl in the flames' picture was destined to become one of the best known ghost photographs ever taken.

The picture very quickly became linked with the story of Jane Churm who, in March 1677, allegedly started a great fire in Wem with a candle. Whilst collecting some stored wood for the fire, the fourteen-year-old girl placed her candle too close to the thatched roof. The roof caught fire and many buildings in Wem, including the Market House, were completely destroyed. The fire was said to have been visible for many miles around. Since then, her guilt-ridden ghost had become associated with Wem Town Hall and reportedly seen on a number of occasions.

Tony's picture received extensive media coverage at the time and various experts were consulted to analyse the photograph. One such expert was Dr Vernon Harrison of the Association for the Scientific Study of Anomalous Phenomena (ASSAP). He concluded that whilst the negative appeared not to have been tampered with, the figure was most likely a burning plank of wood which by chance appeared to look like a little girl. It has to be said that there were no witnesses to the girl being in the flames including Tony himself who said he only discovered her presence when he developed the film. The fire service recorded a video of the blaze and this too showed no sign of the little girl.

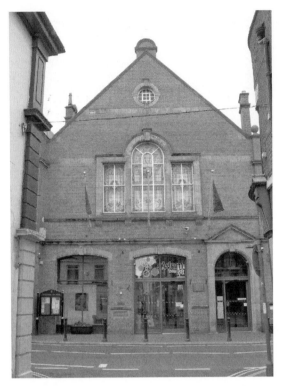

Wem Town Hall.

The little girl in the burning building. (Tony O'Rahilly & Fortean Picture Library)

The author met with Tony O'Rahilly at the time who maintained that he was as curious as anyone as to how the girl had come to appear on his picture. For this reason he was more than willing for the negative to be examined by experts which is how Dr Harrison got involved. Tony had a little darkroom set up in a shed behind his house and did all of his own developing and printing there. One slightly odd aspect at the time was that Tony claimed he could not find any of the negatives preceding the one with the girl on which had been cut out from the rest of the strip. Preceding pictures from the same negative strip of the town hall burning down would have helped to authenticate the image. Various other theories were put forward at the time but for the most part the picture remained something of a mystery.

The story now moves to 2010 when a retired Shropshire engineer, Brian Lear, spotted a little girl bearing a remarkable resemblance to the girl in the flames on a postcard of Wem High Street from 1922. Closer analysis of the details in both pictures reveals that the folds in her bonnet and dress are identical as is the narrow sash she is wearing around her waist. There can be little doubt that this is the source of the picture which intrigued so many people for so long. Tony O'Rahilly sadly passed in 2005 but having met and talked with him I am convinced he believed he was acting in the best interests of Wem by bringing the town hall fire and the story of Jane Churm to the attention of the world's media.

This could have been the end of the story but what was it that prompted Tony to produce the picture in the first place? The association with Jane Churm in the media occurred after the photograph was made public. The answer may lie in an event which took place before the old town hall burnt down. Two workmen were in the hall doing some refurbishment work when they were terrified by a ghostly figure shrouded in a swirling mist which passed directly in front of them. Could this perhaps have been the ghost of Jane Churm come to warn of another fire and the inspiration for Tony O'Rahilly's enigmatic picture?

WHITCHURCH

THE BLACK BEAR
High Street
Whitchurch
SY13 1AZ

The Black Bear is a superb Tudor-style building situated on the corner of High Street and Church Lane in the historic town of Whitchurch. Dating back to 1662, this oak-beamed inn has served as a hostelry since 1667. Noted today for its fine range of wines, real ales and fresh, home cooked food the Black Bear continues to offer a hospitable welcome just as it did in the days when horse-drawn coaches would regularly pull in for refreshment and comfortable overnight lodgings.

As well as well as welcoming regular customers the pub also plays host to spectral visitors who have been seen here by a number of different people. According to owner Mark Sumner, one such ethereal visitor was seen by a friend of his whilst playing dominoes quite late one night. Mark said his friend 'saw a lady sweep through the bar in a long dress and then just disappear through the wall where the old fireplace used to be'. Another figure seen here is that of a man in an old fashioned flat cap who sits in the far corner of the bar. Mark's wife has seen him sitting there and at the time thought it was just someone who had come to see her husband about something. However, on looking away and then back again the man had simply disappeared.

Sarah McCreery used to play dominoes in the pub when a previous landlord, Nigel, was in charge. She recalled a story concerning friend Graham Welch during one such game. They used to play in the top half of the pub where the bar is now. It was possible to see if anyone came in through the door at the bottom. If anyone did come in it was common practice then to shout 'incoming' to landlord Nigel who would then come out from the kitchen or wherever he happened to be. This was before the interior of the pub was fully refurbished and back then the bar ran up through the length of the pub and was quite narrow and dimly lit. Graham spotted a dark shadow coming from the entrance and drifting across the bottom half of the building. After shouting 'incoming' as usual to alert Nigel it soon became obvious that there was actually nobody there

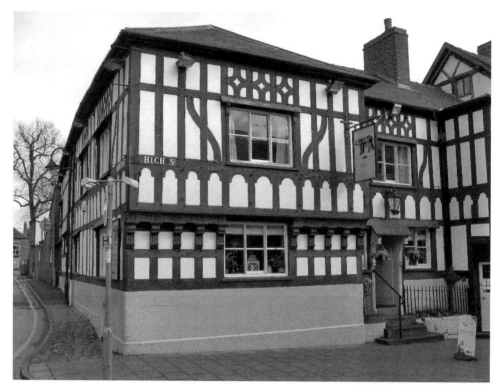

The Black Bear.

and nowhere the figure could have gone. Graham's impression was that it was the figure of a woman, slightly hunched over. A very level headed signalman, Graham is convinced to this day that it was a ghost he saw that night in the Black Bear.

OLD EAGLES
Watergate Street
Whitchurch
SY13 1DP

The Victorian façade of the Old Eagles public house conceals the origins of this Grade-II listed building. One of the oldest properties in Whitchurch, it is thought to date back to the fourteenth century where it most likely started life as a medieval town house. It became a pub in 1868, probably as a result of the 1830 Beerhouse Act which was in force until 1869.

In common with similar stories of disturbances the haunting of the Old Eagles only started a few years back during an internal refurbishment. Immediately following the completion of this work the sound of a young girl singing has, on occasions, been heard coming from the general area of the cellar. Who she is, why she is there and

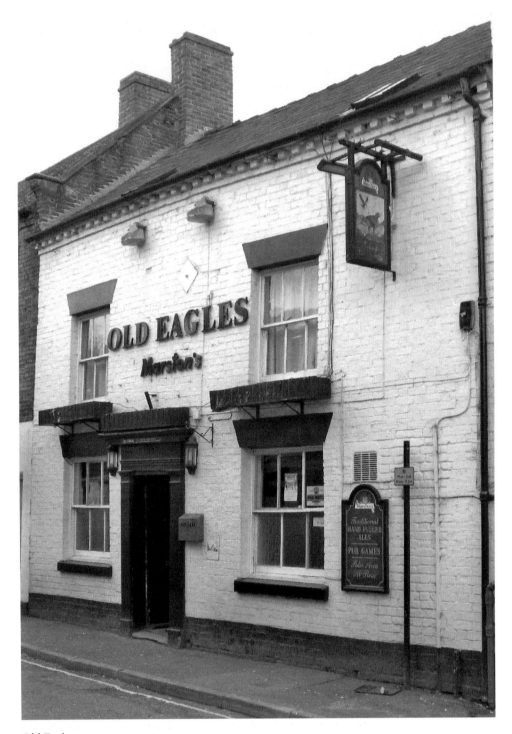

Old Eagles.

what period she comes from is lost to time. It is quite possible that she was some sort of servant girl given that the pub was once a town house and she seems to only inhabit the lower parts of the building. If you visit the pub on a quiet day be sure listen out for a young girl singing to herself. At least she seems to be happy to be still residing at the Old Eagles.

OLD TOWN HALL VAULTS
St Mary's Street
Whitchurch
SY13 1QU

The Old Town Hall Vaults is a community pub renowned for its range of real ales and home cooked food. This Grade II listed building retains many original features including the comfortable little snug with its real fire. The building was first licensed in 1823 by an F. Cammerley but was most likely operating as an alehouse or brew house before this date. In the eighteenth century St Mary's Street was known as Back Street and even today the pub is known locally as the 'Backstreet'.

A plaque on the outside of the building commemorates the birth of composer, Sir Edward German, who was born here in 1862. He was baptised as German Edward Jones but later took the name of Edward German. He was a prolific composer and is probably best remembered for his light operettas such as *Merrie England* and *Tom Jones*. He was knighted in 1928 and died in 1936.

The Old Town Hall Vaults is subject to a great deal of paranormal activity which is often witnessed by staff and customers alike. There is so much going on here that landlady, Sarah McCreery, keeps a diary specifically for staff and customers to record their experiences. Some of the entries relate to poltergeist-type activity where, for example, CDs were seen moving across the back bar towards the CD player and a chair was kicked over in the front bar under the clock even though no-one was near it at the time. After the last customer had left one night the front door was found to be bolted from the inside after he had just opened it and gone through. At times a strong smell of perfume is experienced in the corner of the main bar by the fire although the source of the smell can never be traced before it disappears. A dark figure is also seen moving behind the bar, recently observed by one of the regular customers.

The activity here is not just restricted to the bar areas either. Sarah has had a number of experiences upstairs in the living quarters. Loud thuds have been heard coming from up there when the rooms have been known to be empty. Even more alarming, Sarah was woken up in the early hours one morning by a sound like a gunshot in her bedroom together with a feeling of intense cold even though the heating was fully on. She also hears groans and moaning coming from the area of the landing and sometimes her name is called loudly, 'as if to wake me up; get me up for some reason'.

Staff member, Sue Jones, has experienced the poltergeist activity recently at first hand. They had just stopped serving for the night as Sue relates:

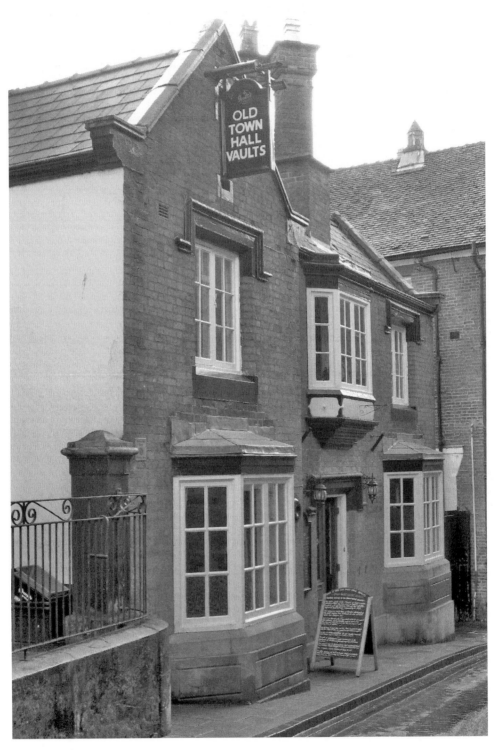

Old Town Hall Vaults.

There were a couple of us left and we all moved through to the front of the pub so there was nobody left behind the bar. We got chatting and started to say how quiet it had been and how nothing had happened for a couple of weeks. All of a sudden we heard as if somebody had got a teaspoon and run it down the whole of the optics. My husband doesn't really have any interest in anything like that but it even made him sit up and say, 'well what on earth was that?' It was just strange because we'd been talking and saying it was quiet and it was almost as if they said, 'No, we're still here!' Very strange.

The night before I visited the pub in early February, staff member June Brassington and her husband Andy had made an addition to the diary. A heavy metal coal bucket is kept to the right hand side of the fire in the snug. At around 10.25 p.m. on the Saturday evening a fire was burning in the grate. Andy happened to be looking in the right direction when the handle on the coal bucket lifted up by itself and flipped over from right to left with a resounding 'clang'. The heavy handle would have required some force to move it over from one side of the bucket to the other. June didn't actually see it but the noise of it startled her and she spun around asking, 'What was that?'

The coal bucket.

Original ghost picture by Sarah McCreery.

Both June and Sue often get the feeling that they are not alone when they open up and close the pub on their own. As June says, 'Sometimes you can feel it and I won't look back when I turn the lights off at night.' Perhaps with good reason as a few weeks before having turned the lights out and without looking back June was physically shoved out through the door by some unseen force. Sue also has felt something touch her when walking through the door and has had her shoulder tapped. Sometimes the feeling that someone is there is accompanied by a strong musty kind of smell. At other times the smell of pipe tobacco fills the bar even though it has been many years since anyone has smoked a pipe in there.

One of June's most vivid experiences in the pub occurred one Sunday morning in May as she was opening up on her own. Right in front of her through one of the windows she saw a strange looking figure dressed in a leather apron walking past the bar. He was dragging something and carrying what looked like a large knife. Sarah has researched the area and this sinister looking figure could have had a more prosaic connection with the past. Apparently at one time the long gone Bradbury's Abattoir was sited immediately behind the pub. The sighting had only lasted for a few seconds before the figure was gone but from the detailed description given by June, Sarah was able to create a picture of the figure. It could well be that he was connected with the long gone abattoir which would explain his dress and the fact that he was carrying a knife and dragging something. Interestingly, at the time of seeing the apparition, June had no knowledge of the abattoir connection with the pub.

The Old Town Hall Vaults is not the pub to go to if you are at all scared of ghosts as was the lady Sarah told me about. 'She just walked into the dining room with her husband and said, "Oh my god you've got a ghost in here I can't stop", and that was it, they were gone!'

WORFIELD

THE WHEEL INN
Worfield
Bridgnorth
WV15 5NR

The Wheel Inn and restaurant at Worfield was waiting to be re-opened at the time of writing. However, it is not the pub itself but the Bridgnorth Road that runs alongside it that is the source of this particular haunting.

A man carrying a petrol can is caught in the headlights of passing cars at night walking away from the pub and the next door petrol station at Worfield, heading in the direction of Wolverhampton. When someone stops to offer him a lift he says that his car has run out of petrol at Tinker's Cross on the rural stretch of road leading towards Wombourne.

Stuart Garlick, who remembers picking up the hitchhiker one night, said that apart from being dressed in slightly out of date clothing, as far as he was concerned there was nothing the least bit unusual about the man. Stuart even noticed a definite whiff of petrol from the can the man was carrying which suggested he had only just filled it up at the Worfield garage, the only petrol station for many miles around. The hitchhiker told Stuart his treasured Triumph TR8 sport's car had run out of petrol on his way back home from work.

When Tinker's Cross is reached the TR8 is clearly seen parked on the grass verge at the crossroads and the hitchhiker thanks the driver profusely and goes to fill up the petrol tank of his car. When the driver checks their mirror to move away, just as Stuart did that night, there is no sign of the hitchhiker or the car. The isolated crossroads is completely deserted. Both hitchhiker and car have suddenly, and silently, disappeared. At the time of Stuart's experience with the mysterious phantom hitchhiker in October 2000, the petrol station at Worfield didn't even open at night.

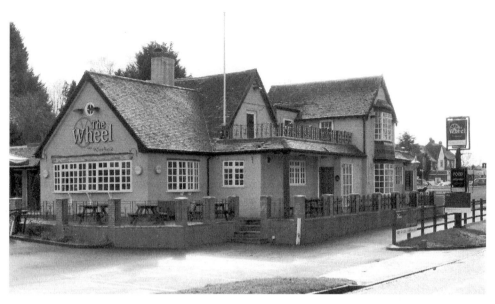

The Wheel Inn.

BIBLIOGRAPHY AND FURTHER READING

Beer and Spirits – Andrew Homer and David Taylor (Amberley Publishing, 2010)

Ghosts, Murders & Scandals of Worcestershire II – Anne Bradford (Hunt End Books, 2009)

Four Centuries at the Lion Hotel – John Butterworth (John Butterworth, 2011)

Haunted Holidays – Anne Bradford and David Taylor (Hunt End Books, 2002)

Haunted Inns – Marc Alexander (Muller, 1973)

Haunted Inns and Taverns – Andrew Green (Shire Publications, 1995)

Haunted Pubs and Inns of Shropshire – A Scott-Davis and A. S. Homewood (Artscape, 1991)

Haunted Shropshire – Allan Scott-Davies (The History Press, 2009)

Our Haunted Kingdom – Andrew Green (Fontana/Collins, 1973)

Shropshire Ghost Stories – Sally Tonge (The History Press, 2007)

Shropshire's Historic Pubs – Jan Dobrzynski (The History Press, 2009)

Some Ghostly Tales of Shropshire – Christine McCarthy (Shropshire Libraries, 1988)

Strangest Pubs in Britain – Strangest Books (2006)

The Haunted Inns of England – Jack Hallam (Wolfe Publishing, 1972)

The Haunted Pub Guide – Guy Lyon Playfair (Harrap, 1985)